Michael Jacobs

NUDE PAINTING

MAYFLOWER BOOKS
NEW YORK

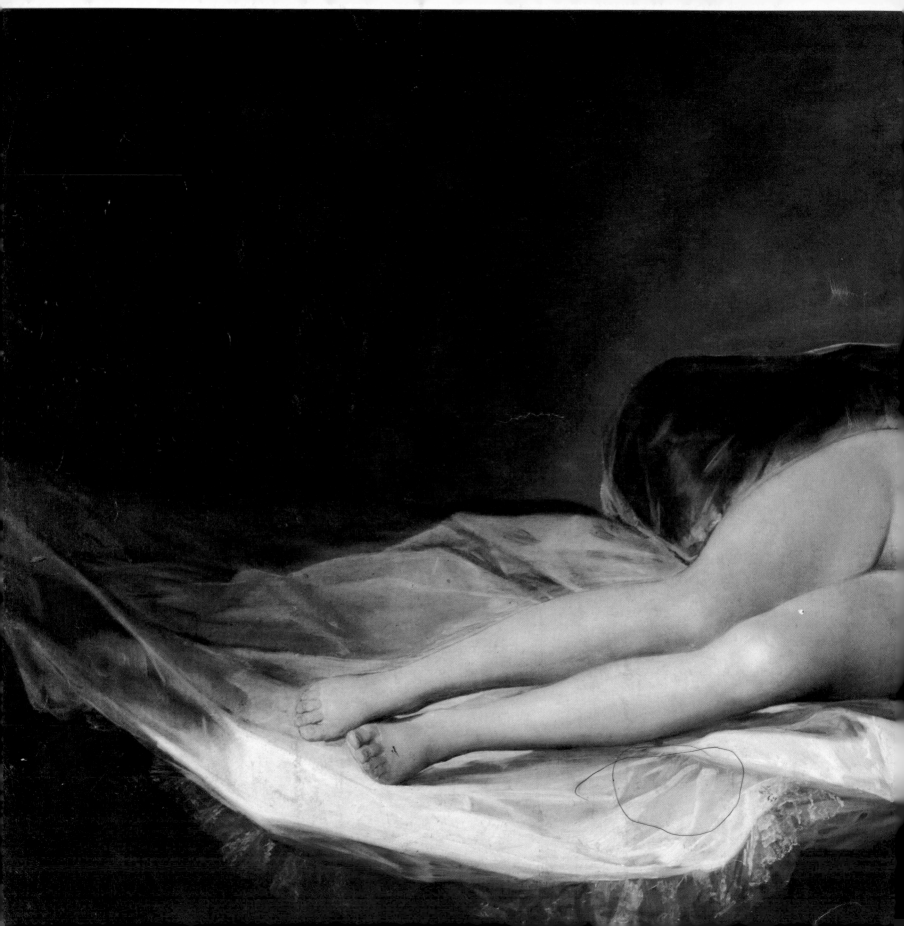

Michael Jacobs

NUDE PAINTING

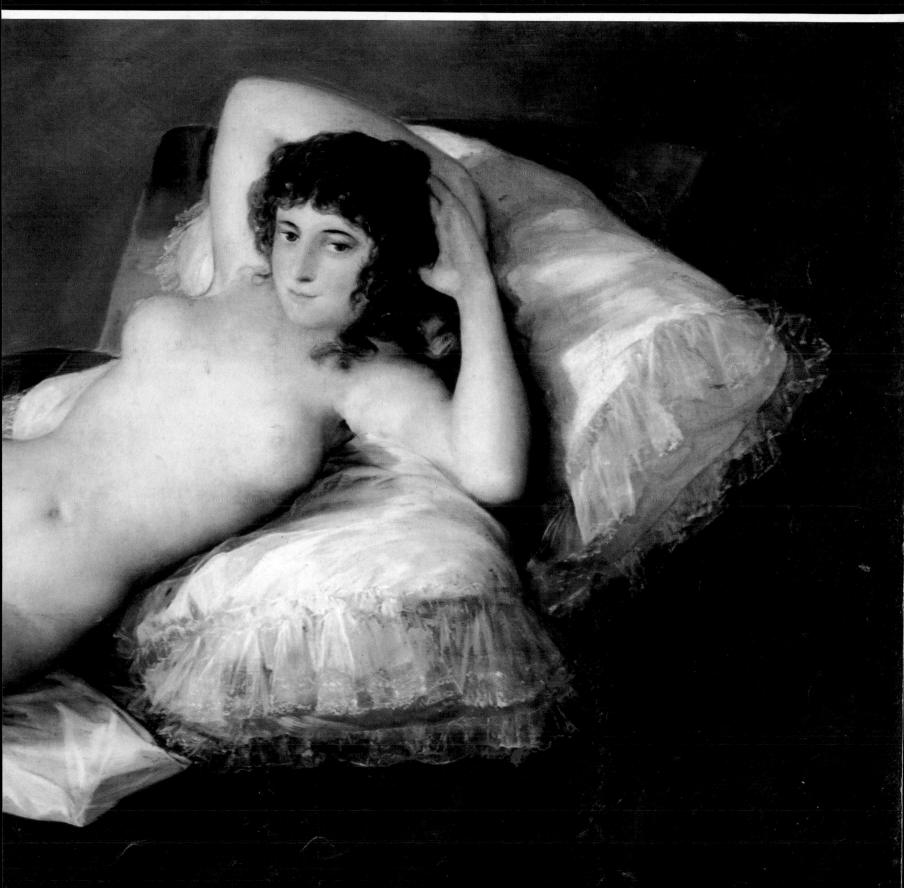

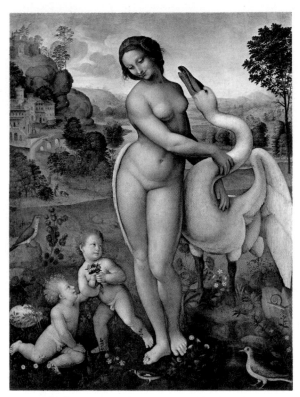

OVERLEAF **Goya:** *Maja Desnuda*, 97 × 190cm, 1796?

Leonardo da Vinci: *Leda*, 112 × 86cm

MAYFLOWER BOOKS, INC.,

575 Lexington Avenue, New York City 10022.

© 1979 by Phaidon Press

All rights reserved under International and Pan American Copyright Convention.
Published in the United States by Mayflower Books, Inc., New York City 10022.
Originally published in England by Phaidon Press, Oxford.

No part of this publication may be reproduced, stored in a retrieval system, or transmitted, in any form or by any means, without prior written permission of the publishers. Inquiries should be addressed to Mayflower Books, Inc.

Library of Congress Cataloging in Publication Data

JACOBS, MICHAEL, 1952–
 Nude painting.

 1. Nude in Art – History. 2. Painting – Themes, Motives – History. I. Title.
 ND1290.5.J3 757'.22 78-25561
 ISBN 0–8317–6465–1
 ISBN 0–8317–6466–X pbk.

Filmset in England by SOUTHERN POSITIVES AND NEGATIVES (CPAN), *Lingfield, Surrey*
Manufactured in Spain by HERACLIO FOURNIER SA, *Vitoria.*
First American edition

Correggio: *Leda and the Swan*, 152 × 191cm, c.1532–3

The 'tender emotion and sweet voluptuousness' which Stendhal had experienced as a child in front of three naked bathers, expressed itself in his later life in an overwhelming love of the works of Correggio. He confessed they had affected the whole spirit of his last great novel, *The Charterhouse of Parma*. Little is known about Correggio's life, which was largely spent in relative obscurity in the provincial environment of Parma and surroundings. The *Leda*, which depicts a maiden seduced by Jupiter in the form of a swan, and a copy of a companion piece, the *Io*, shocked a later owner, Louis, Duke of Orleans, for their blatant eroticism, and in the late 1720s he ordered the faces of the principal figures to be destroyed; the face of the *Leda* was repainted in the early nineteenth century by the German artist, Schlesinger.

THE FRENCH WRITER, STENDHAL, looking back on his childhood, vividly remembered being shown by his art teacher a painting of three naked women bathing in an idyllic landscape. This work, probably an indifferent eighteenth-century decorative piece, seems to have been the first painting to awaken in the young writer his interest in the fine arts; it came to represent for him his 'ideal of happiness', inspiring a 'mixture of tender emotion and sweet voluptuousness'. What Stendhal poetically expressed was characterized more coarsely by the Surrealist painter and photographer, Man Ray, when he himself explained his early interest in the arts: 'I had not seen a naked woman in the flesh . . . I had gloated over Greek statues and Ingres' nudes, had made drawings of these ostensibly as exercises in art, but inwardly knowing full well it was the woman that interested me equally.'

The appeal of the painted nude has frequently very little to do with art, and many readers casually browsing through the pages of this book are really looking for an erotic sensa-tion, presented under the auspices of culture and a reputable publishing firm. Considerable historical precedence can be offered for this type of behaviour. The most austere person-alities of the past, not necessarily noted for their patronage of the arts, have suddenly — like Cardinal Richelieu who went to extraordinary lengths to acquire Rubens' *Bath of Diana* — turned into passionate collectors at the prospect of buying a nude. Not only has the nude inspired such depths of enthu-siasm, but also considerable controversy, ranging from actual physical damage to canvases, interference by authori-ties to, more commonly, moralizing polemics and jeering titters. Even now, continuing attitudes of prurience are re-flected in writings on the subject, which, by some conven-tion reserved for respectable books of this sort, take great pains to avoid specific mention of parts of the body associated with sexual functions. The major survey of the nude in art, by Lord Clark, is subtitled *A Study of Ideal Art*, a cautious response to the hint of lewdness which the principal title

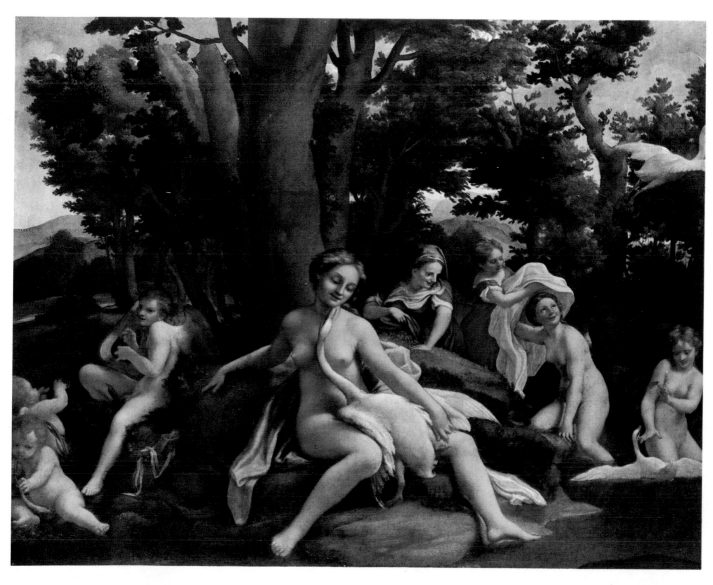

might suggest. Moreover Clark's distinction between the naked and the nude immediately endows an aura of sanctity over the works he discusses. Such high-minded defensiveness leads frequently to pure hypocrisy; for example, in a recent book on Titian's mythologies, the author feels he has to justify the 'frankly erotic nature' of a group of reclining Venuses by stressing that this eroticism is 'managed without insistence or lascivious appeal'. Such an attitude is most explicitly stated in S. Alexander's influential *Beauty and Other Forms of Value*: 'If the nude is so treated that it raises in the spectator ideas or desires appropriate to the material subjects, it is false art, and bad morals.'

For those who approach art without the inhibitions of the scholar, the concept of the nude must seem a highly attractive reason, and certainly one of the most persuasive grounds for becoming an artist. The image of the artist as someone who spends his day copying from a beautiful naked model is, indeed, central to the popular notion of his life, and also sufficient cause for the great envy. In the classic nineteenth-century novel of bohemian life, the Goncourts' *Manette Salomon*, the eponymous heroine, a model, becomes the embodiment of delirious sensual desire, still more tantalizing for being beyond the boundaries of touch. More often than not, one has to substitute the Goncourts' feverish visions of

Delacroix: *Mademoiselle Rose*, 81×65cm, c.1821–3

Life-painting, as opposed to life-drawing, was not generally practised as an academic discipline until the nineteenth century. Delacroix's work dates from his apprenticeship as an artist and depicts the nude in more detail than any of his later studies. The popular notion of the artist always ending up by sleeping with his model was confirmed by the example of Delacroix who noted, discreetly using the Italian word *chiavitura*, the names, together with the amount of money paid, of all the girls who had posed and slept with him.

the naked model, with the less glamorous reality of the most academic discipline in art still to survive. The traditional French term for a painting or drawing from life, an *académie*, emphasizes what has essentially been the primary function of academies of art, ever since their foundation in Renaissance Florence. In seventeenth-century Italy, with the spread of small private academies, many of these institutions were founded simply as convenient places to have a model posing. The importance of studying from the nude was certainly not as an exercise in the sensual, or, for that matter, realistic rendering of flesh, but rather a way to achieve an understanding of human proportions, the essential basis of

Courbet: *The Studio of the Painter*, 359×598cm, 1855

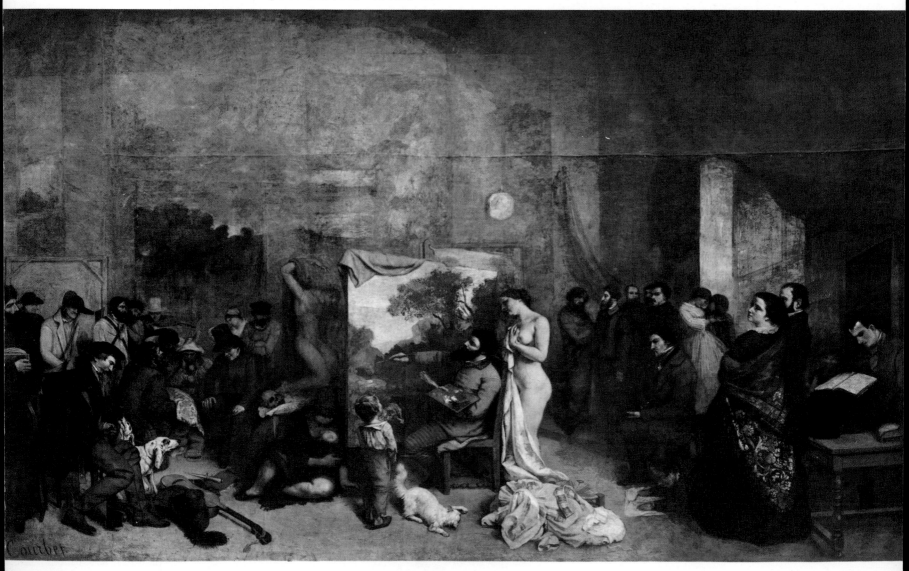

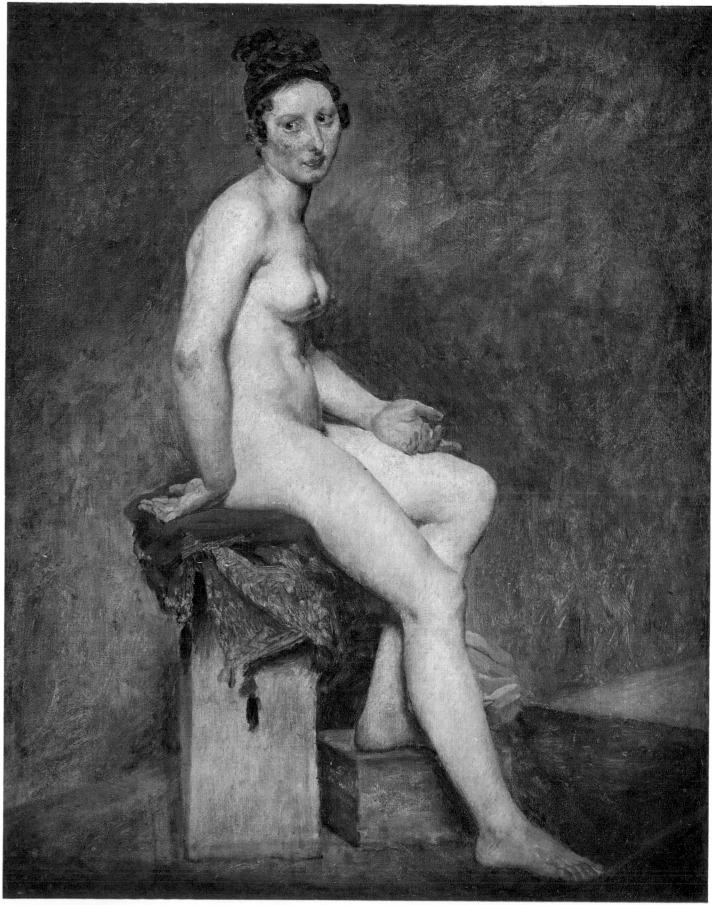

Delacroix: *Mademoiselle Rose*

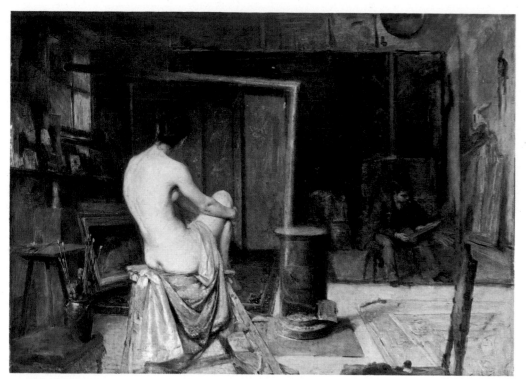

Malhoa: *The Painter and his Model,*
93 × 127cm

all classical art. Before being allowed to copy from the model, the inexperienced artist would be expected to copy meticulously from casts or engravings of antique sculpture. When he came to the naked body itself, he was thus influenced by classical precedent, which would be reinforced by the pose chosen for the model. These artificial poses were vigorously adhered to right up to this century, and Manet considerably annoyed both the model and the teacher by demanding more natural ones. The naked model became a depersonalized object, and, as such, copying from the nude was hardly conducive to erotic reverie. Even so, like everything connected with the subject, the history of nudes modelling has been marked by controversy. In a famous letter of 1562 to the Florentine Academia del Disegno, the sculptor Ammananti accused himself of indecency because he had modelled so many nudes. What in his case might be regarded as Counter-Reformatory zeal has nonetheless been typical of many sub-

sequent attitudes towards the female model. Surprisingly, women were allowed to pose in almost no public art schools until as late as 1850. The presence of female models even in the private environment of Rembrandt's studio was sufficiently unusual to prompt an early biographical anecdote about one of the artist's pupils undressing so as to appear like Adam to the model's Eve; both were appropriately expelled. Later on, in the eighteenth century, Hogarth wittily commented on the exceptional use of female models in Vanderbank's Academy in St. Martin's Lane, claiming that this made it 'more inviting to subscribers'. The woman model became inevitably synonymous with a prostitute, and in Galsworthy's *Forsythe Saga*, the ultimate decline of the impoverished but once respectable family is represented by the wife being forced to pose secretly to an artist.

The sense of immorality and guilt provoked by the naked body has invariably been the antidote to dreams of pure

Holbein: *The Dead Christ,* 30·5 × 200cm, 1521

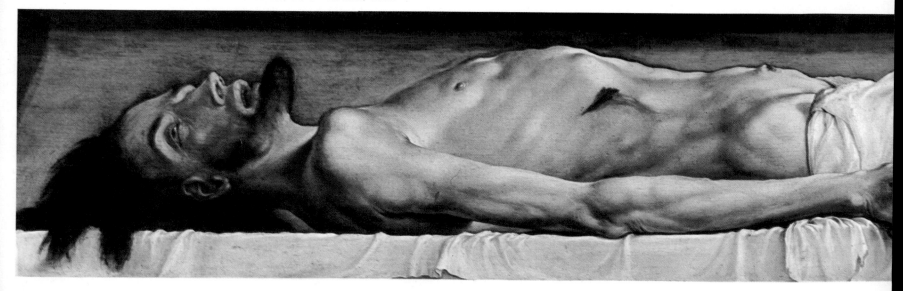

voluptuousness. Associated with this has been a morbid awareness of differences between antiquity, where nudity was a natural part of life, and the drably clothed present with all its complexes. This loss of belief in the purity of the human body was most strongly confirmed by Christian dogma, with its consciousness of the original sin of Adam and Eve. Thus with the religious fervour of the Middle Ages the nude came to symbolize exactly the opposite of what it had stood for in antiquity. The naked body, subject to the appalling transformations of time, acted as the most potent reminder of the transience of human life. The medieval association of the naked and the dead remained current in Northern Europe right into the Renaissance, at a time when more classical notions of the human body were being revived. In fact the extreme degrees of realism attained in Northern painting of the fifteenth and sixteenth centuries could make possible some of the most strikingly direct and shocking images of the

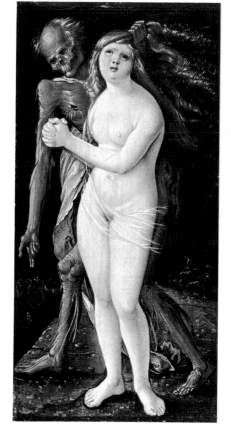

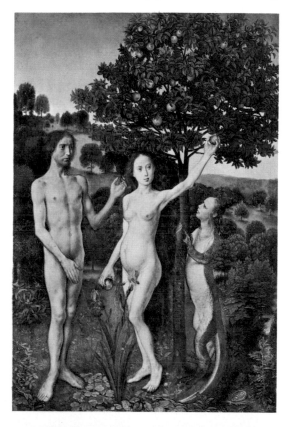

Van der Goes: *Adam and Eve,* 34 × 23cm, c.1470

Baldung: *Death and the Maiden,* 30 × 14·5cm, 1517

body. Holbein's *Dead Christ,* for instance, with its penetrating insistence on the grotesque details of morbid decay, has a pathological intensity almost unrepeated in Western art until the mortuary studies of the Romantic painter, Géricault.

Holbein's picture makes one recoil in horror, but even with other medieval nudes, when our reaction is not so strong, one can never fully relax. The two figures of Adam and Eve from van Eyck's Ghent altarpiece (c.1426–32/34), two of the first truly realistic painted medieval nudes, induce a sense of physical embarrassment in the spectator, especially when seen in the context of the celestial paradise which they flank. Hugo van der Goes' version of the same subject, another Flemish work of slightly later date, shares similarly realistic qualities, but Goes' Eve is clearly intended as a sensually provocative figure; the sinuous pose of her body

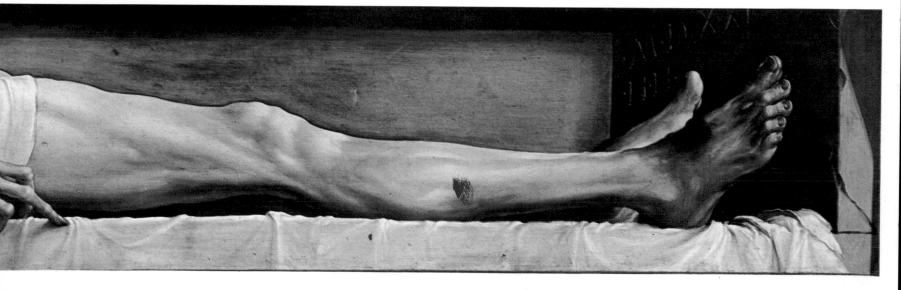

gives emphasis to her small round breasts, as tempting as the apple she holds. Virtually all other medieval nudes of women carry the same ubiquitous overtones of evil and death. A school picture of Memling in Strasburg, portraying a young girl whose bulbous stomach and small breasts once again corresponds to the medieval ideal of beauty, is on closer inspection a representation of vanity. This is symbolized by the mirror she holds, an object which, reflecting only the superficial aspects of a person, came to represent the evanescent quality of earthly beauty. The required moralizing tone of the Memling takes on frightening proportions, as the eye moves to its two accompanying panels, with their vivid evocations of the terrors of hell. Inevitably, however, it is by a German artist, Baldung, that the horrifying potential of the medieval nude was exploited to the full. Baldung's own *Vanitas* does away with the calm idyllic setting of the Memling to show a darker and more sinister landscape. The lurking tension behind this picture reaches screaming-point in the Basel *Death and the Maiden*, an anguished and deeply felt study of corporal inadequacy.

In spite of being a climactic expression of medieval preoccupations, from a purely formal point of view, Baldung's *Maiden* differs considerably from the archetypal medieval nude. Although there is no evidence that Baldung ever visited Italy, his nude painting, its forms fuller and more harmoniously balanced, displays the classical proportions associated with Italian art. This change in cultural orientation was very largely due to the influence of Dürer. Dürer paid two visits to Italy, in 1495 and 1505, and came under the influence of the leading Italian painters of the time, including Bellini, Leonardo and Mantegna. In an engraving of 1504, representing Adam and Eve, Dürer's treatment of the subject could hardly be more different than that of Van der Goes. His intention was to present to the Northern public a model of ideal beauty based on such classical prototypes as the statues of the *Apollo Belvedere* and the *Medici Venus*. Prior to this engraving, Dürer had made a whole series of constructed drawings, inspired by those of Vitruvius, in which he had tried to create the perfect male and female nudes by mathematical and geometrical means. This reduction of the human body to a pseudo-scientific grid was the best corrective to its representation as mortal flesh. Dürer was nonetheless a contradictory figure, fascinatingly poised between Italy and Germany, and in a later version of Adam and Eve, also intended as a portrayal of perfect humanity, his ideas of beauty have significantly changed. The figures, more slender and elegant, display the unsteadiness and lack of confidence more characteristic of the medieval nude. The most manifest examples of Dürer's inherently Germanic personality are provided by two remarkable nude self-portrait drawings of 1512–3 and of 1522. In the first, apparently drawn for the purpose of consulting a doctor, the naked artist points to a mark on the left side of his abdomen with the inscription underneath explaining that 'where the yellow spot is . . . there it hurts'; the spot corresponds exactly with the spleen, once regarded as the source of all melancholy disease. In the second drawing, the artist shows himself in the guise of the Man of Sorrows, haggard, emaciated and already wracked by the malaria which he contracted while searching for a dead whale in the swamps of Zeeland and which was to kill him in two years' time. The nude self-portrait, a form not revived until the Expressionist era, represents an attitude towards the human body which takes little delight in physical perfection, but is rather a merciless exposition of the most hidden scars and anxieties. It was a painful summary, in fact, of all that the medieval nude had come to stand for.

It is with a sense of relief that one turns to Italy. Botticelli's *The Birth of Venus*, popularly regarded as the epitome of the pubescent Renaissance spirit, does, indeed, mark a departure in the history of Western painting in its portrayal of a calm classical world. Influenced though we are by the

Baldung: *Harmony* (or *The Three Graces*), 151 × 61cm, 1547

OPPOSITE, LEFT **Baldung:** *Music*, 83 × 36cm, 1529

OPPOSITE, RIGHT **Baldung:** *Vanitas*, 83 × 36cm, 1529

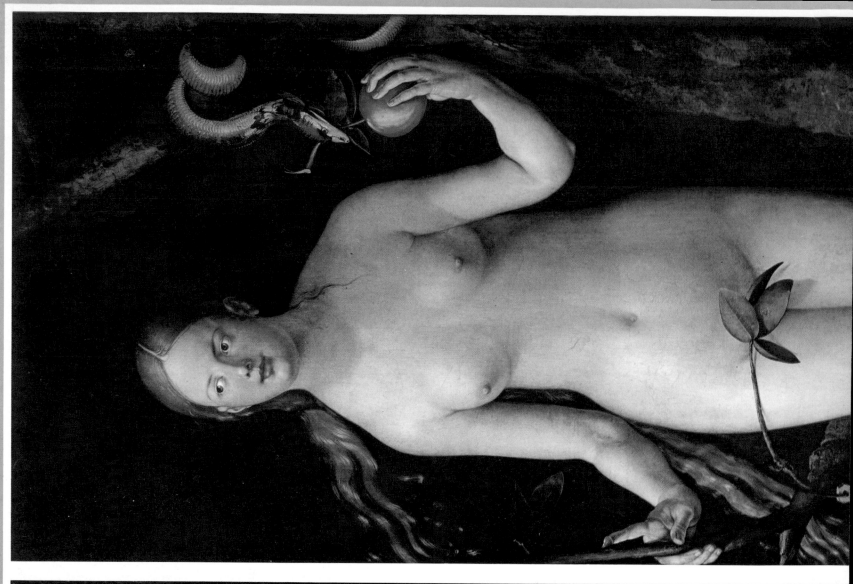

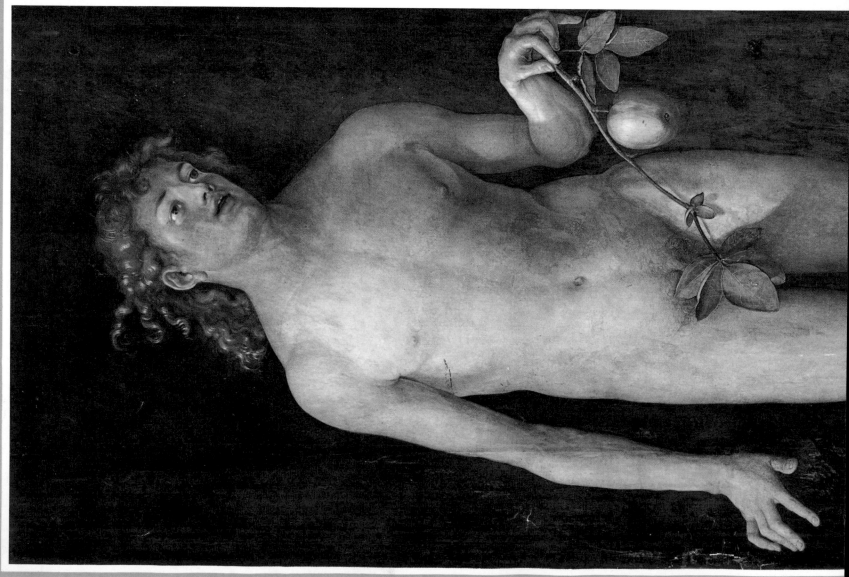

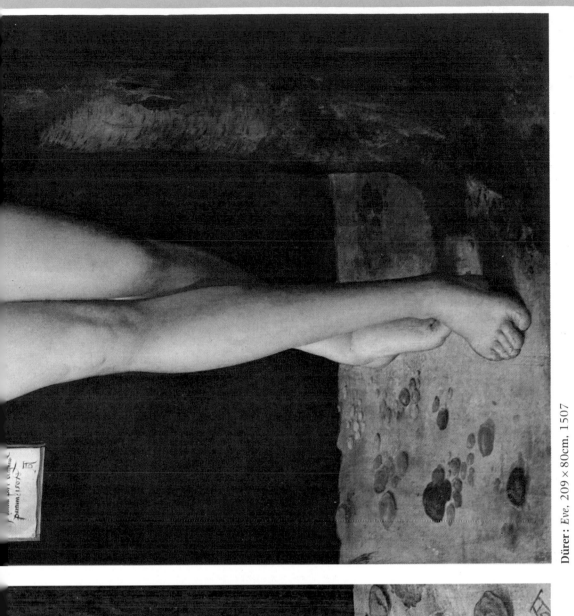

Dürer: *Adam*, 209 × 80cm. 1507

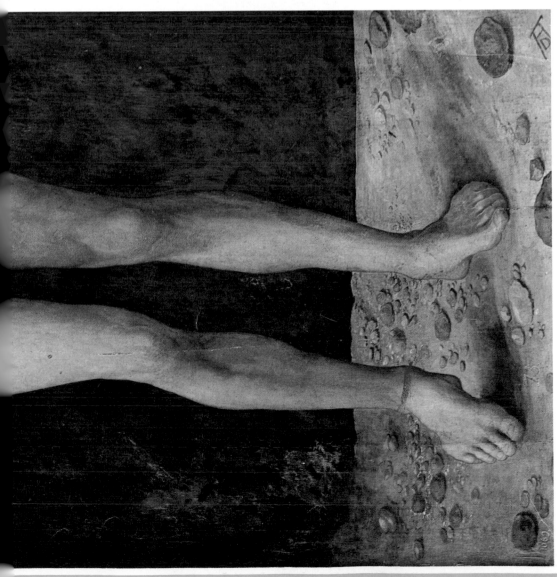

Dürer: *Eve*, 209 × 80cm. 1507

work's use in advertizing new soap brands and hair sprays, it nevertheless exudes a refreshing vitality, and its popularity over all other works by the artist testifies to the extraordinary hold which the nude exerts on the imagination. In spite of the uncomplicated nature of our response, the work's critical history has not been so straightforward. From the very time Botticelli was re-discovered in the nineteenth century, critics like Ruskin have recognized that the figure of Venus, her pose oddly combining that of the *Medici Venus* with the Uffizi *Baptized Christ* by Verocchio, nonetheless displays the sinuous linear elegance, the sloping shoulders and slender physique of a medieval nude. It was these factors of the painting which led to its most influential description, by the late nineteenth–century aesthete, Walter Pater. To him, Botticelli's Venus, like all his 'goddesses of pleasure', emanated 'a shadow of death in the grey flesh and wan flowers'. Few now would agree with this morbid interpretation, but it is interesting that a writer, whose *Renaissance* was accused as a work of harmful immorality and whose aesthetic philosophy was an open invitation to the senses, should feel the need to qualify a voluptuous figure in the same way that the moralizing medieval mind would consider symbols of vanity. But the fear of simply enjoying a sensuous picture manifests itself more strongly in the remarkable amount of print which has been devoted to the painting's meaning. Since *The Birth of Venus* belonged to a friend and pupil of a leading Neo-Platonic philosopher, Marsilio Ficino, art historians have been reluctant to see the work for what it most obviously represents. As the picture is a straightforward account of the birth of beauty and pleasure, the prosaic interpretation of the artist's intentions in terms of simply creating a provocatively arousing work seems most justified. Unaccustomed as the Renaissance patron would have been to such, almost life-sized, naked classical deities, the intentions must have certainly succeeded.

The universally reverential attitude towards the art of the

Botticelli: *Birth of Venus*, 175× 278cm, c.1480

Botticelli's first mythological painting was probably the *Primavera* of 1477; this work, later seen by Vasari in the Medici villa at Castello, was commissioned by Lorenzo di Pierfrancesco, a cousin once removed of Lorenzo di Medici and a friend and pupil of the Neo-Platonic philosopher, Marsilio Ficino. The same patron probably commissioned the *Birth of Venus*, which also hung at Castello in Vasari's time. Both pictures, the first of their kind in their depiction of near life-sized classical deities, do not, however, seem to have been inspired by any obvious classical sources, and their elegant, elongated figures and tapestry-like compositions make them closer in spirit to the International Gothic style. The summary treatment of landscape in a work like the *Birth* led to Vasari's suggestion that Botticelli simply threw a sponge at his canvases to produce the backgrounds. In spite of very involved allegorical interpretations of the *Birth*, it can be seen as straightforward narrative. According to classical legend, Venus, born from the froth of the sea caused by the castration of Uranus, arose near the island of Cyprus (Cythera), to where she was blown by the Zephyrs; she was greeted by the Seasons, daughters of Jupiter and Themis.

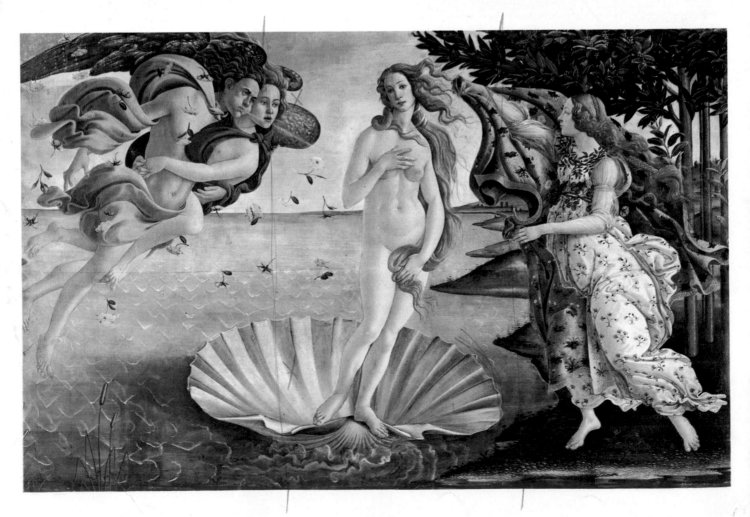

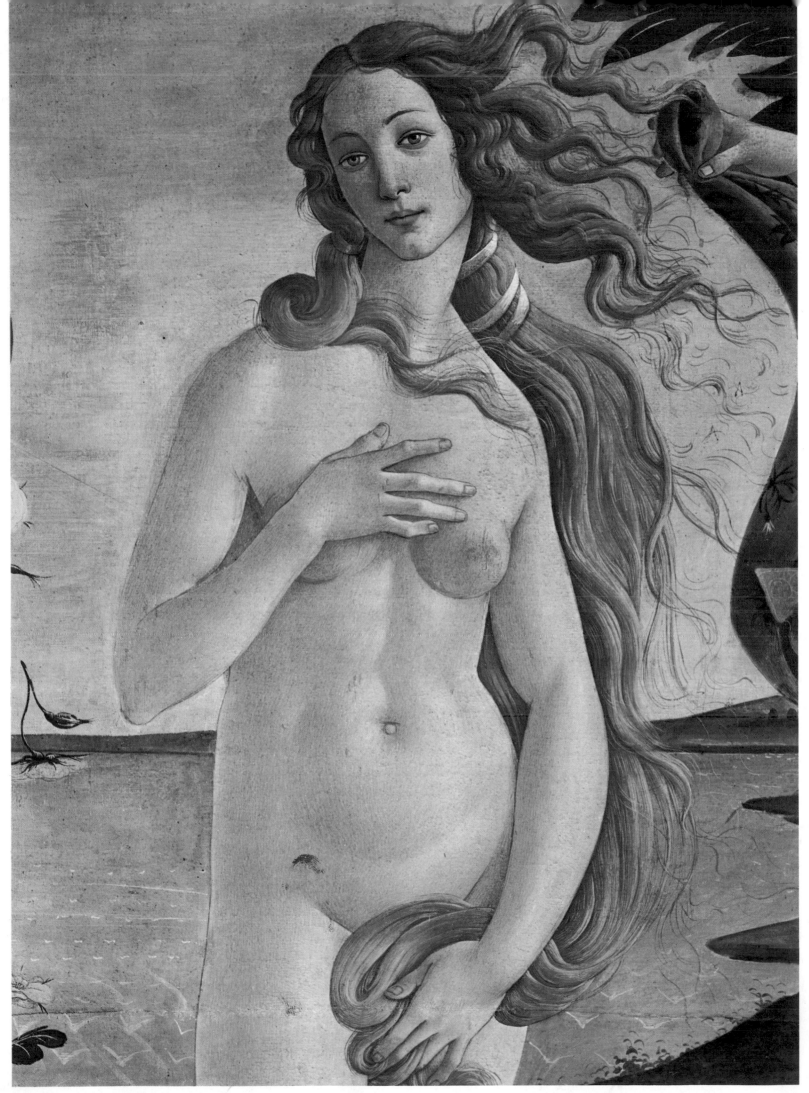

Botticelli: *Birth of Venus* (detail)

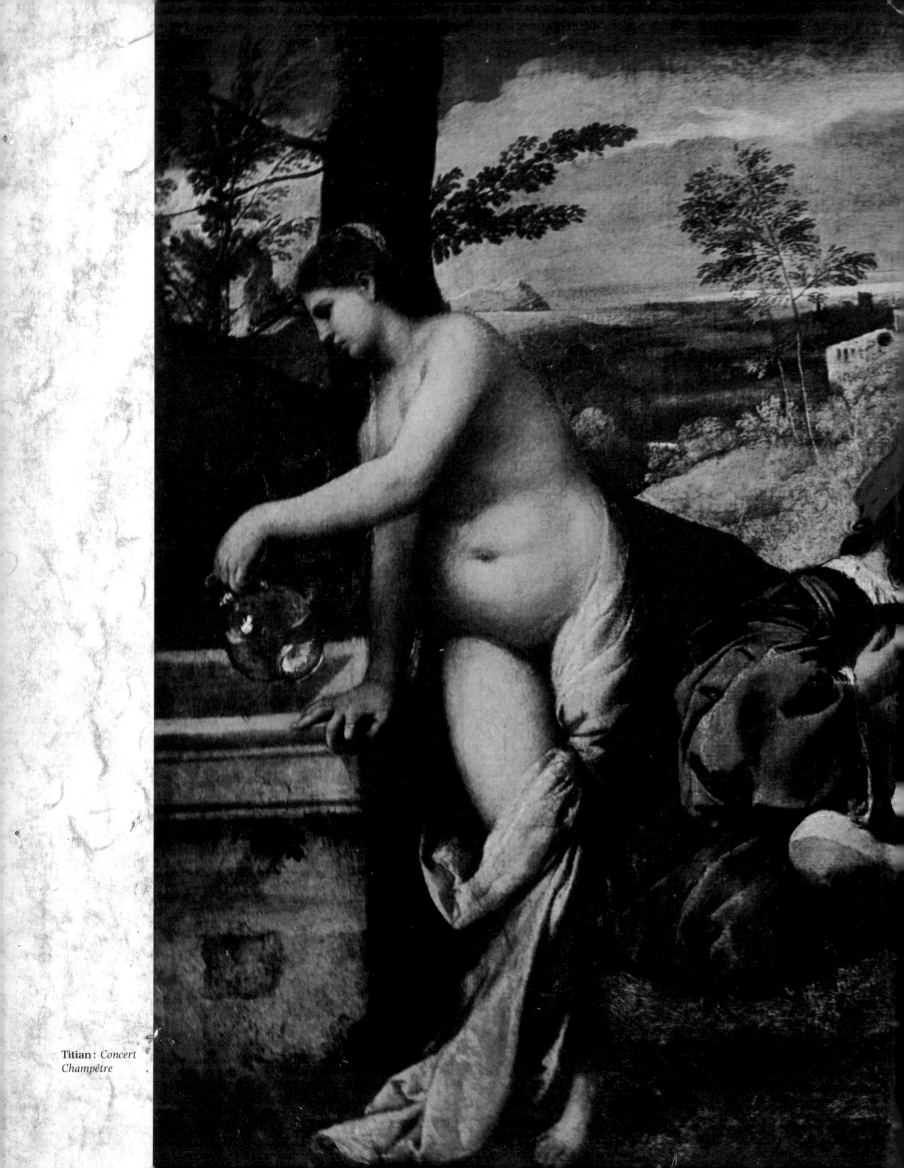

Titian: *Concert Champêtre*

Pages 16–17. Titian: *Concert Champêtre,* 110×138cm, c.1510

The work, which is not mentioned in any contemporary document or literature, is first heard of in a collection of 1671. For a long time it was considered to be one of the masterpieces by Giorgone, but the execution is now generally ascribed to the young Titian, even if heavily under the influence of his great Venetian predecessor. The languorous atmospheric quality of the work (the legacy of Giorgone) is matched by a sense of incipient vitality (the active discourse of the two seated men, the movement of the nude on the left) which is to break more openly to the surface in the works of Titian's maturity. Unfortunately, as Manet pointed out, much of the colour of the painting has been lost, and the work has been further altered by the addition of canvas strips on all four sides, particularly at the top. Its exact meaning is mysterious, and many ingenious interpretations have been put forward, including the suggestion that the two nude women may be figments of the men's imagination. Even if interpreted as simply a pastoral idyll, the work is not just a poetic and effete recreation of this world, but rather an embodiment of an erotic daydream in contemporary terms.

Renaissance has resulted in many of its sensuous masterpieces being accorded the status of altarpieces. Moreover a combination of over-exposure to these works together with the art historian's constant need to validate them in terms of classical prototypes is not conducive to freshness of response. The concept of the Renaissance nude immediately conjures up images of the dreariest academic concoction, for it has become almost impossible now to dissociate the subject from vague notions of the ideal. The search for ideal form has always been the basis of the art academy. However, after the Renaissance institutions which aimed systematically to dehumanize the naked figure for the benefit of art, the subsequent history of the academy has made it difficult for us to appreciate the initial excitement of this process. The story from antiquity ubiquitously quoted by academic theorists of the past, that of Xerxes creating his ideal nude by choosing to portray the most perfect parts of all the beautiful women of Alexandria, holds the most attractive possibilities for the artist. It is not that far removed in spirit from a recent speculation in a popular newspaper about the ideal pin-up girl who would combine the 'face of Lindsay Rudland, the shoulders and bosom of Vanya, the bottom of Geraldine and the legs of Jilly Johnson'. There are certainly many paintings of the Renaissance which aspire to little other ideal than that of the senses, but there still remain many barriers to our appreciating them in this way, not least of which is their subject-matter.

The world in which the vast majority of the nudes of the past are to be found, the world of mythology, is one which is largely alien to contemporary sensibility. It is generally believed that mythological paintings hold secrets only fathomable to the most diligent and erudite scholar. But although a considerable amount of knowledge is required to appreciate fully many of these paintings, equally, a large number of them have no other pretext than the depiction of naked bodies. Certain subjects particularly appropriate for this, and which have been immensely popular from the Renaissance onwards include 'the Judgement of Paris', no more than a classical nude beauty contest, 'the Three Graces', an opportunity to depict three naked female bottoms from a variety of angles, 'the Bath of Diana', a voyeur's paradise of bathing beauties, and the various seductions of

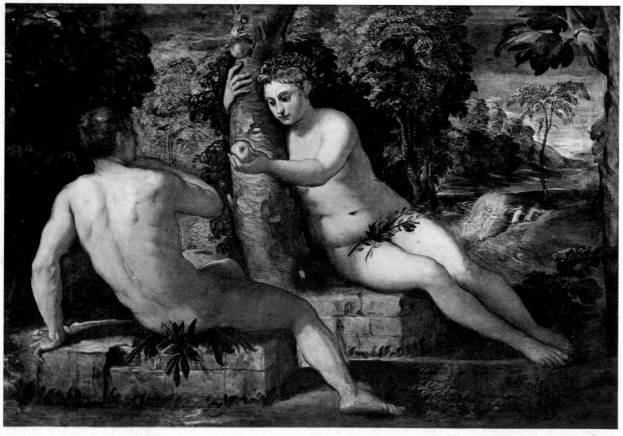

OPPOSITE **Titian:** *Sacred and Profane Love* (detail)

Tintoretto: *The Temptation of Adam,* 150×220cm

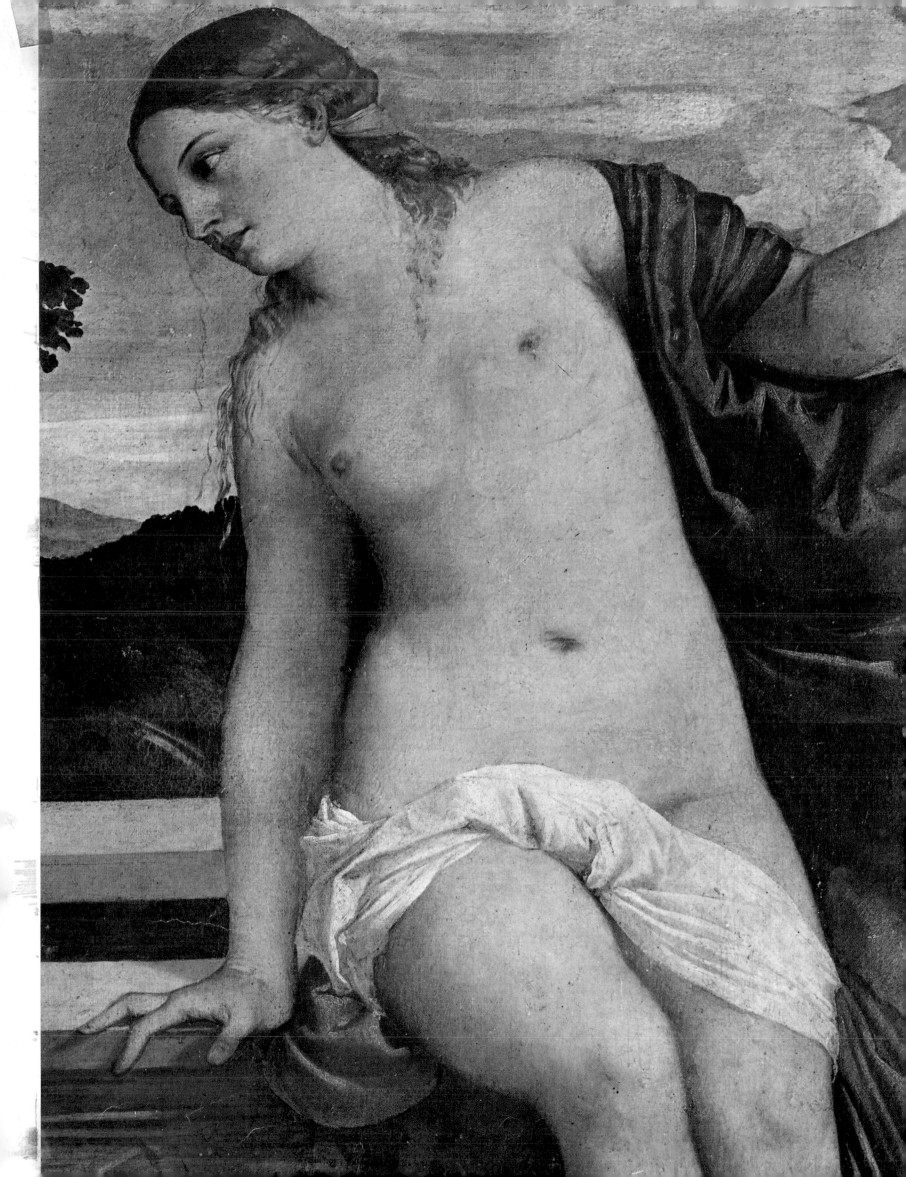

Jupiter, an ideal theme for the suggestive depiction of sexual intercourse.

Two paintings at the beginning of the sixteenth century stand out as crucial for the development of the sensuous mythological nude. The first, the Dresden *Venus*, begun by Giorgione but with landscape and drapery added by Titian, shows an atmospheric treatment of the linear two-dimensional grace of Botticelli. The second, the *Concert Champêtre*, probably completely executed by Titian, nonetheless, owes to Giorgione the full-bodied sensuality of the figures, both

voluptuously blending into the warm tonality of the whole. Once again many have speculated on the meaning of this work, for the combination of nude female figures and fully dressed men in contemporary costume, argues for no obvious mythological or allegorical content. Whatever the intention behind the work, this odd combination must have had as provocative an effect as did the work it later inspired — Manet's *Déjeuner sur l'Herbe*. The new sensual vision of Giorgione permeates all of Titian's later works, an artist who is to become the greatest and most prolific painter of the

Titian: *Sacred and Profane Love*, 115 × 279cm, c.1514

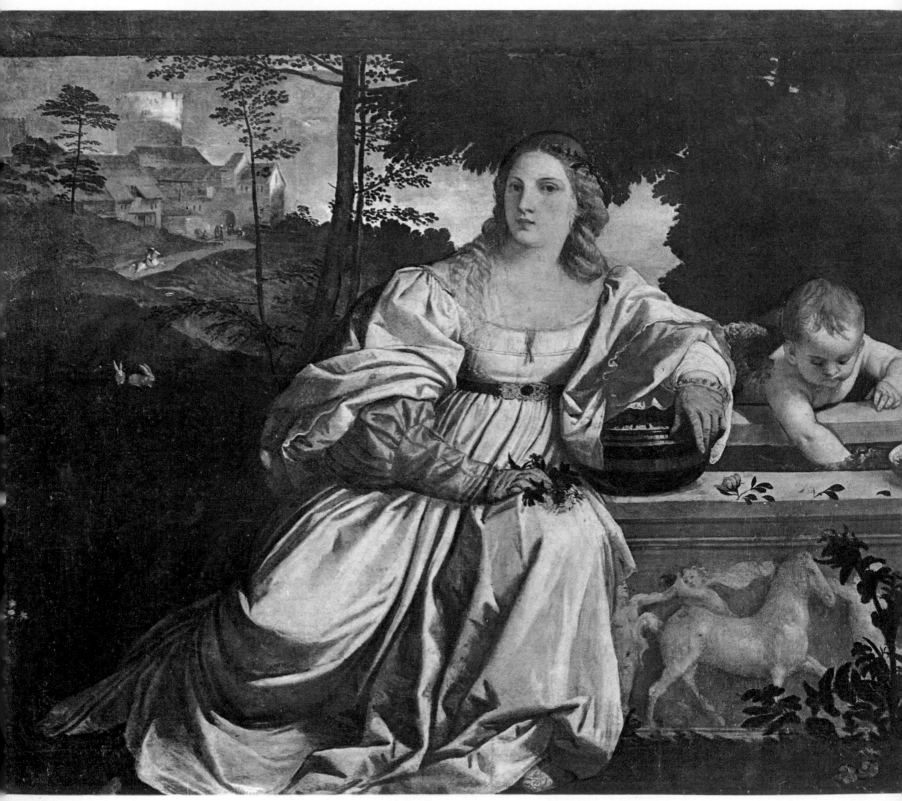

nude in the sixteenth century. Another of his early works, the *Sacred and Profane Love* (1514) again titillatingly contrasts the naked with the clothed; while in the Middle Ages the profane figure would have certainly been the unclothed one, in Titian's work the latter, though inspiring far from sacred thoughts, probably represents the higher ideal of beauty. Whatever the painting's exact meaning, one is transfixed by the presence of rosy-tinted flesh, which finally commands our entire attention. Similarly, in the later Prado *Bacchanal of the Andrians* one's eye eventually rests on the naked Ariadne in the foreground, her posture expressive of total abandon to the orgiastic delirium of the senses. A recent cartoon showed a gallery visitor removing this section of the canvas, with the caption: 'I don't know much about art, but I know what I like.' The concentration on this one area of the painting was also shared by many of the innumerable later copyists of the work. One of these admirers was Poussin, whose Dresden *Venus* obviously reflects the Ariadne, but goes even further by opening her legs.

The essayist Hazlitt considered that no artist other than Titian had given to the nude 'the same undulating outline, the same pulpy tone to the flesh, the same animal spirits, the

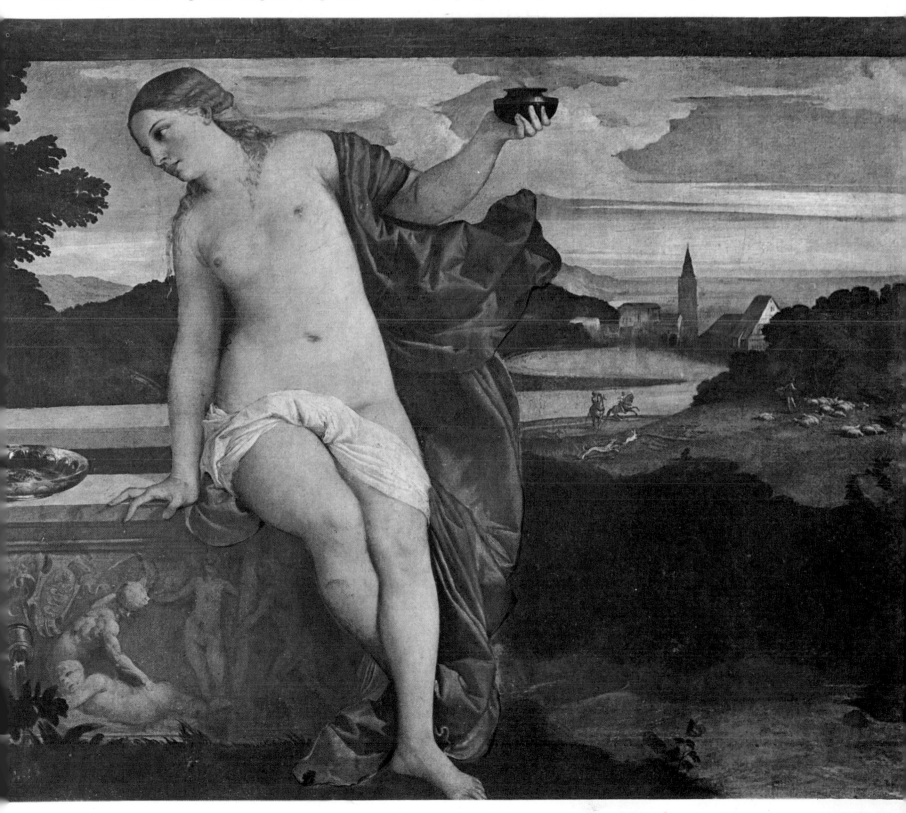

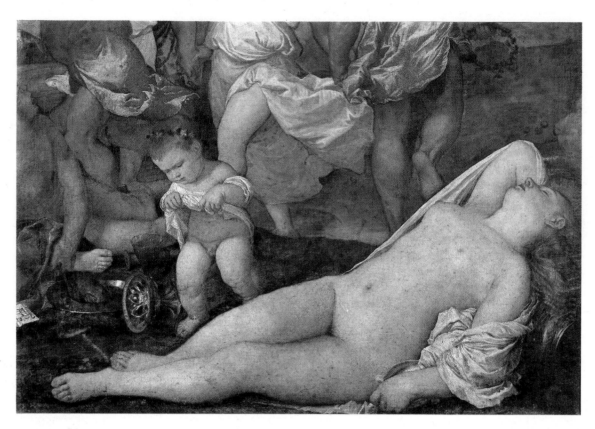

Titian: *Bacchanal of the Andrians* (detail)

same breathing motion', had created figures 'in which you saw the blood circling beneath the pearly skin'. The extraordinarily life-like quality of Titian's nudes intensifies as the artist grows older, and even the overall colouring of these works takes on the tonality of flesh. A painting in the Prado, one of a series entitled *Venus with an Organ-player*, shows a man in contemporary costume staring transfixedly at the vagina of his naked companion. Whether, as has been suggested, it is an illustration of the equal importance of hearing and sight, the work is nevertheless a hymn to the senses, and

the now more robust and palpably fleshy nude almost physically imposes herself on us. In Titian's two versions of the *Danaë* legend, the story of a maiden's seduction by Jupiter in the form of a shower of gold, the urgency increases so that in the second of the two, when Danaë's last vestige of modesty (a discreet covering of drapery) has been removed, one feels the heavy pounding of a heart as the maiden's legs stretch apart in ecstatic anticipation of the gilded semen. But there is more to come. In two works, in Edinburgh, of Diana and her companions, the sweaty confusion of desper-

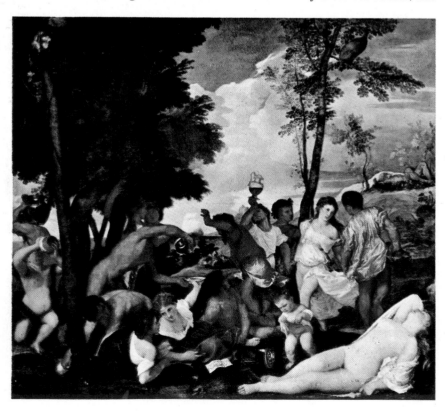

Titian: *Bacchanal of the Andrians*, 175×193cm, c.1520–1

This was one of three mythologies by Titian which formed part of a series of canvases in Alfonso d'Este's Alabaster Chamber in his castle at Ferrara. The actual subject of the work is the 'Stream of Wine on the Island of Andros'. Titian's characteristically dynamic and erotically charged interpretation is summarized in the figure of the foreground sleeping nude, which was the most copied detail of the work and which at one stage (probably when the canvas was owned by Cardinal Aldobrandini at the end of the sixteenth century) was modestly shielded by a fig leaf. This fig leaf appears in Rubens' copy, now in Stockholm, a free interpretation of the work turning Titian's sophisticated pornography into a scene of healthy entertainment. Like so many of the famous Renaissance mythological paintings, Titian's, along with his *Garden of Love* in the same series, ended up in the Spanish Court; before being sent from Naples in 1637, it created a great stir when exhibited there, and — an early instance of the distress caused by the export of a work of national heritage — the painter, Domenichino, was recorded as having wept at such an important painting leaving the country.

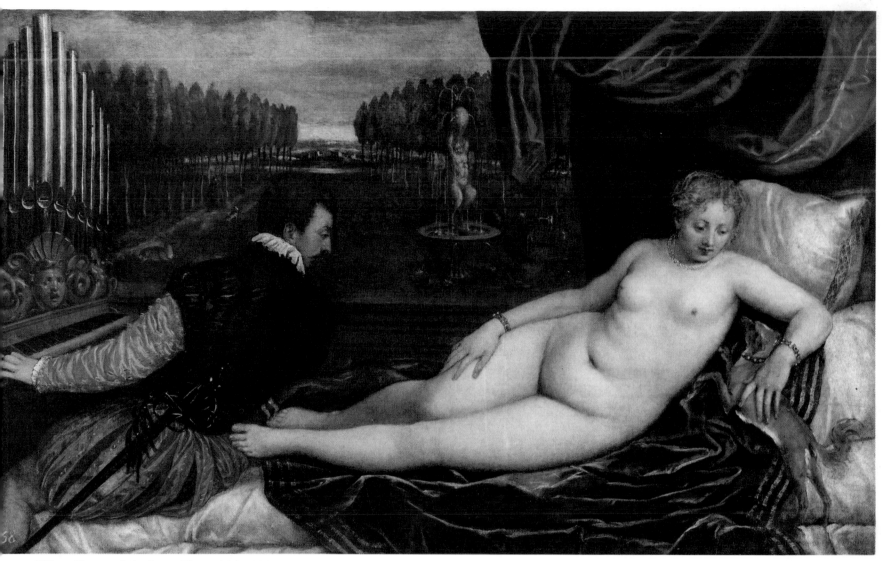

Titian: *Venus and the Organ-Player*, 136 × 220cm, c.1550

Titian: *Danaë*, 129×180cm, 1554

Titian's first version of this painting was done in Rome during 1545–6, and was greatly admired by Michelangelo for its colouring and 'lively manner'. From the mid 1550s there was a great surge in Titian's activities as a painter of mythologies, perhaps partly the result of the sensuous inspiration provided by his new mistress, but more importantly, because of the accession to the throne in 1555 of Philip II of Spain, a well known lover of erotica. Titian's second version of the *Danaë* was delivered to him in 1554; not only has the maiden's drapery been removed, but also the cupid in the earlier work has been replaced by an old maid (an addition to Ovid's text found in Boccaccio's *Genalogie Deorum*), whose voracious attempts to collect the gold pieces serve as a humorous commentary on the mental state of expectation of Danaë. Technically, as well, this painting marks a considerable development over the earlier version. One wonders what Michelangelo, whose one reservation about the latter picture was its lack of drawing, would have thought of a work in which the acts of painting and drawing have become inseparably part of the same process, creating the freedom of technique which is the hallmark of Titian's late style.

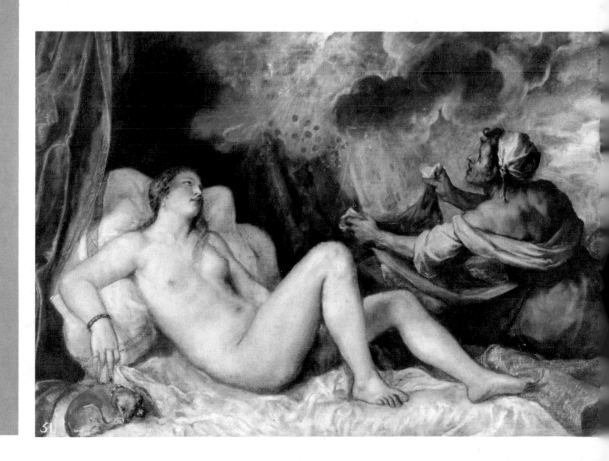

23

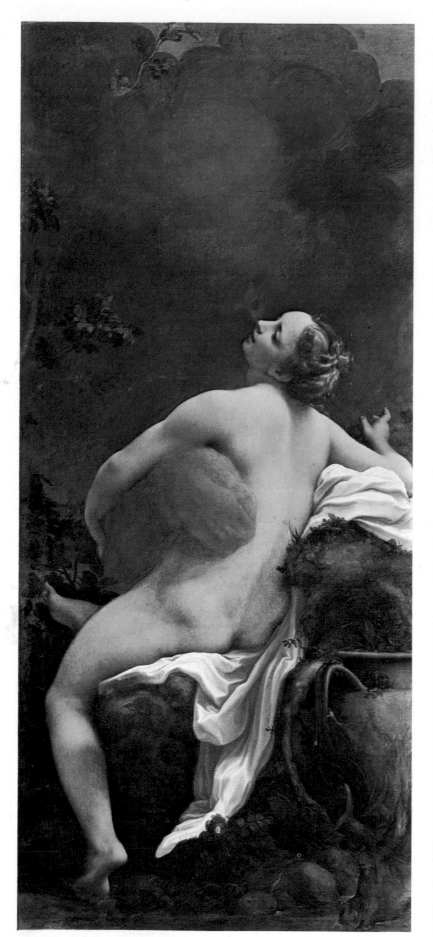

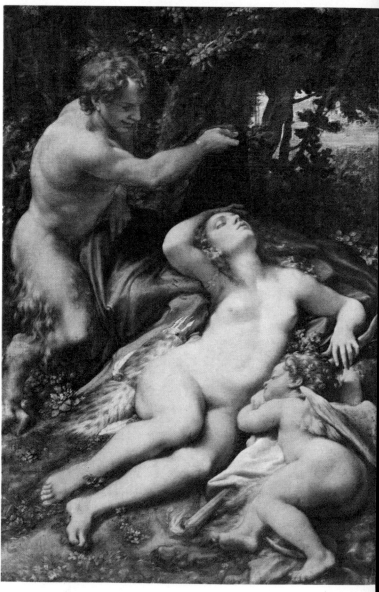

Correggio: *Io*, 163·5×70·5cm, c.1530

Correggio's known mythological work is restricted to two series of canvases, two allegorical scenes of 1523–4 for the Mantuan Court of Federico Gonzaga, and four scenes of Jupiter's seduction for the Emperor Charles V. The *Io* portrays Jupiter as a cloud seducing a nymph, whose obvious satisfaction is mirrored in the enthusiastic way a stag is shown slaking water (an event that is an gratuitous addition to Ovid's text). This is one of Correggio's irrefutably erotic works which embarrassed Victorian connoisseurs like Eastlake, who censured the artist for his success in these scenes. An eighteenth-century engraving of the painting was accompanied by a salacious poem begging the viewer to forgive Io ('What Woman could Withstand the Clasps of Jove?') and concluded with the lines: 'If this be Fiction, Oh! be Tender, Fame:/Not Io, but Correggio is to Blame'. The work's reputation was such that it appears, partially covered by a curtain, in the background of Hogarth's study of social degeneration, the *Morning Levée* from his *Marriage à la Mode*.

logical world of Correggio seems distinctly relaxing. In the latter's *School of Love*, where a faun has just uncovered a seductive and gently writhing beauty, the erotic dynamism of Titian gives way to caressing luxuriance. The atmospheric suggestiveness of Correggio's nudes is totally ahead of its

Correggio: *The School of Love*, 190×124cm

ately crawling flesh creates an oppressiveness of sensuality unprecedented in art. Finally, in Titian's last work, the Vienna *Nymph and Shepherd*, the dynamics of flesh and blood are revealed in their rawest state, all distracting movement, colour and meaning stripped away by the rigorous harshness of the artist's late style, leaving just the quivering buttocks, the fundamentals of desire.

After the hot-house atmosphere of Titian, the mytho-

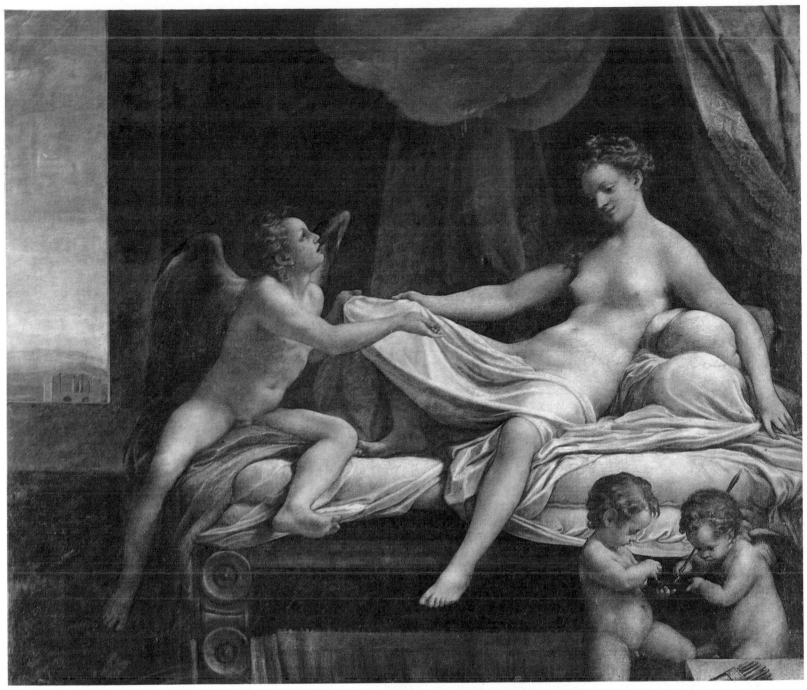

Correggio: *Danaë*, 161 × 193cm, c.1530

Titian: *Nymph and Shepherd*, 42·5 × 53·5cm, 1570–5

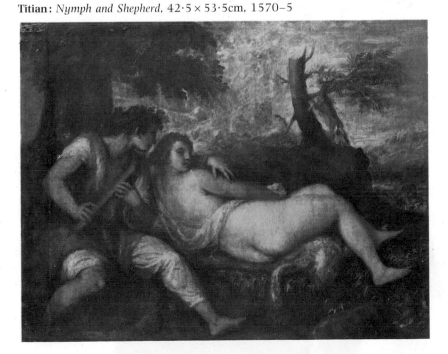

time, and the artist did not acquire prominent status until the eighteenth century. In the middle of the nineteenth century, however, critics found it increasingly difficult to reconcile his obvious greatness as an artist with his, at times embarrassing, sensuality. The erotic climax of his art was reached in a series of four paintings representing the passions of Jupiter. Almost contemporary with Michelangelo's heroic and sexless Leda, Correggio's shows, in explicit narrative detail, the whole playful game of seduction. The maiden is depicted in several parts of the canvas, coyly retreating from the swan's advances, giving in to the teasing foreplay of the animal's neck, and finally rising up radiantly refreshed after their delightful encounter. A much more difficult subject was that of Io, but one perfectly suited to Correggio's command of erotic suggestion. Very unlike and more subtle than the eroticism of Titian is the way in which the cloud slowly envelops the naked figure so that every part of her body is tinged with the gradually mounting excitement of sexual bliss. The differences between the two artists are clearly brought out in their versions of the *Danaë* legend, the immediately dramatic impact of Titian's seduction contrasting with the much more static event by Correggio, and the

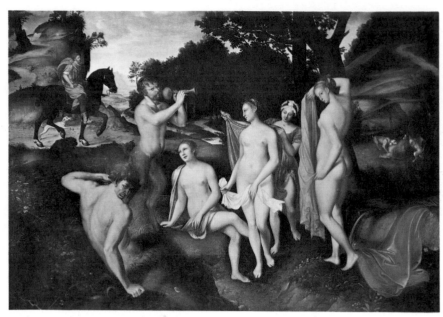

Clouet: *Bath of Diana*, 78 × 110cm, c.1545

Bronzino: *An Allegory of Love and Time*, 146×116cm, c.1545/6

The exact significance of this typically complex Mannerist allegory is not clear. Vasari, probably describing this work from memory, summarizes its essentials as a 'naked Venus kissed by Cupid, with Pleasure, Play and accompanying *Amori* on one side, and on the other, Fraud, Jealousy and other Passions of Love'. Whatever the specific meaning, under the guise of a moral demonstration of the consequences of erotic passion, the work perversely delights in what it supposedly condemns. The supreme example of sophisticated Court pornography, by Bronzino, the painter to Cosimo di Medici, Duke of Tuscany, the work found an appropriate home in the equally precious surroundings of the French Court of Francois I.

sensuality in the latter's painting is the result of the taunting, self-conscious pose of the heroine and the aggravating distractions provided by the *amoretti*.

This mixture of self-consciousness and the titillating irritation of small, unnecessary details is a key to the understanding of the Mannerist nude. Technically and formally, Bronzino's *Allegory of Love and Time* is diametrically opposed to anything we have seen so far. Whereas both Titian and Correggio revelled in the evocation of tactile flesh, Bronzino's

nudes attract us for their very unnaturalness; the fiery nature of sexual excitement – the mingling of tongues, the fingers squeezed against a nipple, the strangely curvilinear protuberance of a bottom – becomes endowed with the sensation of tempting perversion. Distortion of the figure, unnatural colouring, and an excessive use of nudes in often ridiculous contexts (the heritage of Michelangelo), are to be characteristic of many works in its wake. Prefiguring this style is Palma Vecchio's *Bath of Diana*, a sixteenth-century version of Ingres' *Turkish Bath*, displaying a plethora of figures artificially posed so as to enhance their attractiveness.

Outside Italy, equally precious attitudes to the nude were adopted. In sixteenth-century France these took the form of

Palma Vecchio: *Bath of Diana*, 77·5 × 124cm, c.1520

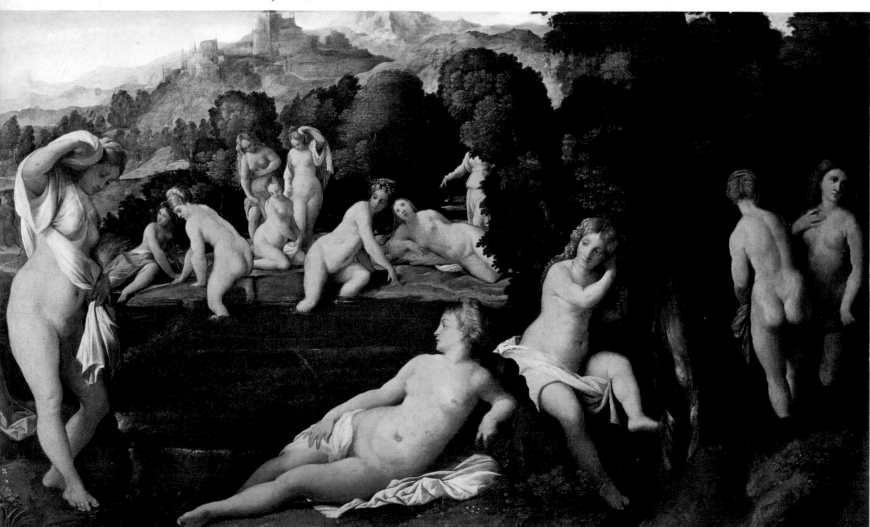

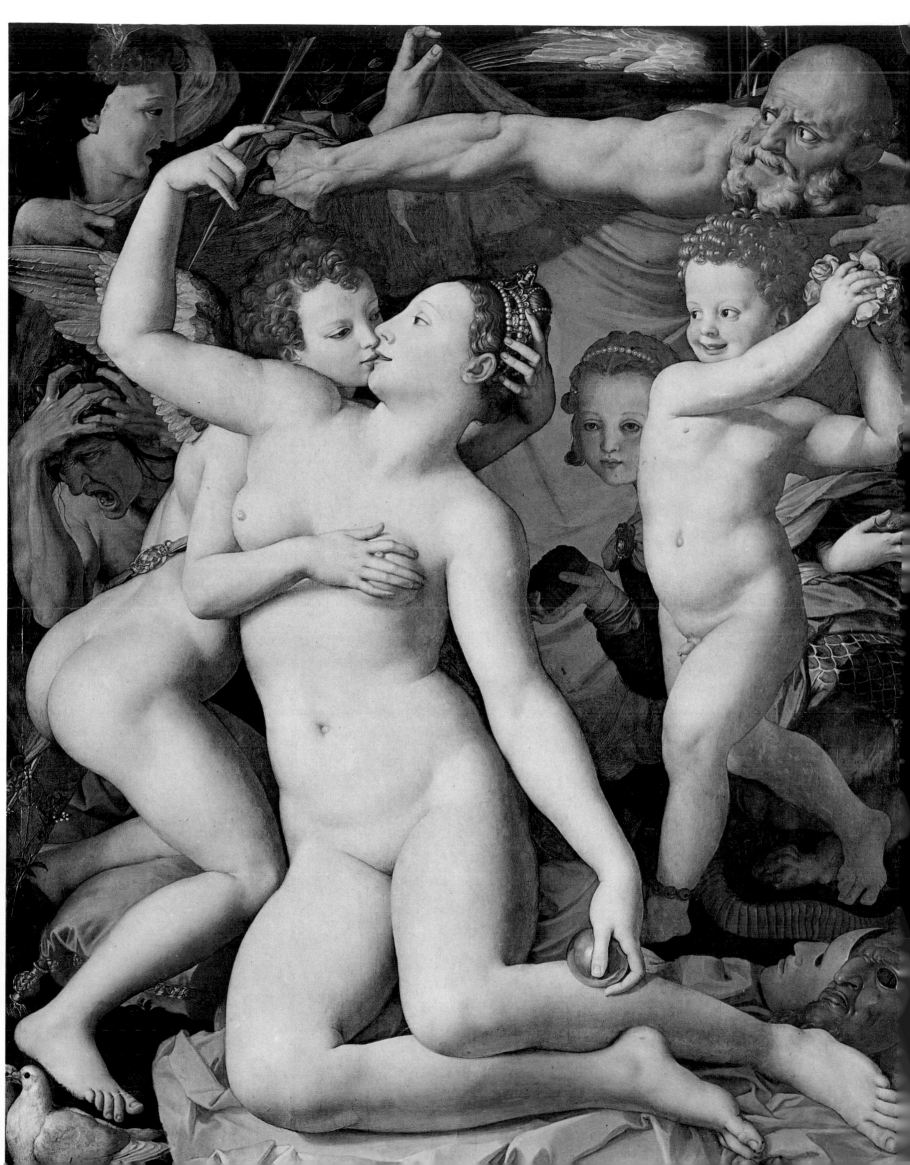

ubiquitous representations of Diana, who became the supreme cult figure of the Court. It is easy to appreciate how this beautiful goddess of virginity could hold such immense attraction for a public, like that of Bronzino, who found beauty more appealing when distanced from reality. In this guise of the tantalizingly unattainable, she is portrayed in a full-length portrait from the Fontainebleau School: tall, lithe and graceful, dispelling us by her unnatural proportions, yet beckoning us with a searching expression in her eyes.

The lack of preciousness in Titian's nudes, together with their raw dynamism, was not paralleled again until those of

Rubens in the seventeenth century. Rubens, whose art, in its love of movement and reaction against languorous affectation, epitomized major tendencies of the Baroque, is the artist most commonly associated with the whole subject of nude painting. To the modern public the Rubensian nude is synonymous with an absurdly plump woman, an ideal of beauty not generally sympathetic to our own. The popular image of Rubens as a rather vulgar figure is ironical in that, although he painted more nudes and from more angles than any other artist in history, his sensuous mythological paintings were perhaps the least erotic in intention. In the *Rape of*

El Greco: *Laocoon,* 137 × 172cm, 1610

OPPOSITE **Fontainebleau School:** *Diana as a Huntress,* 192 × 133cm, c.1550

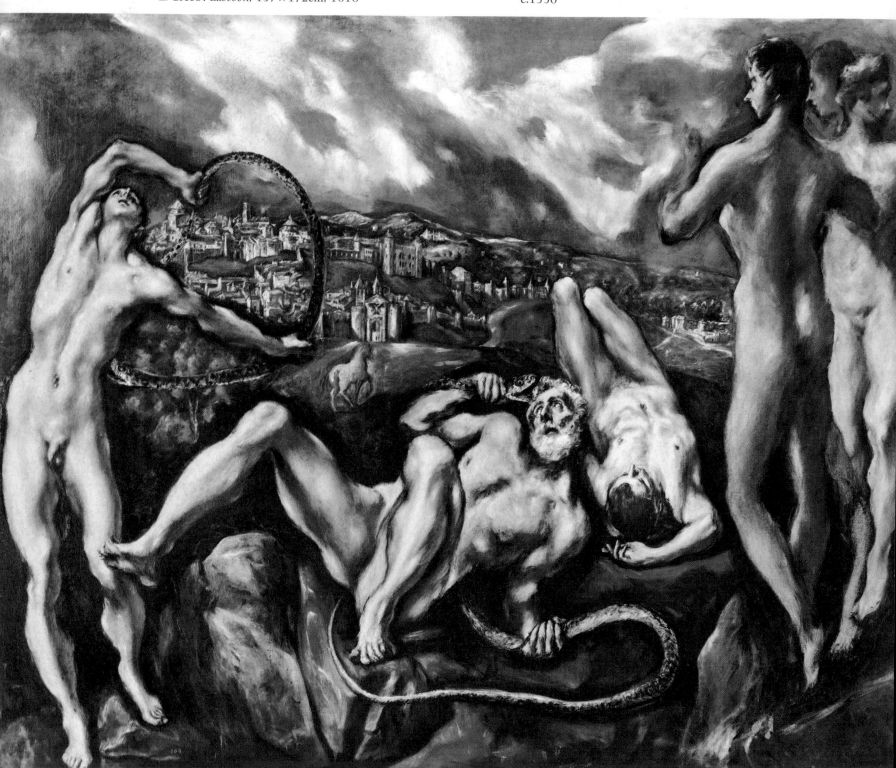

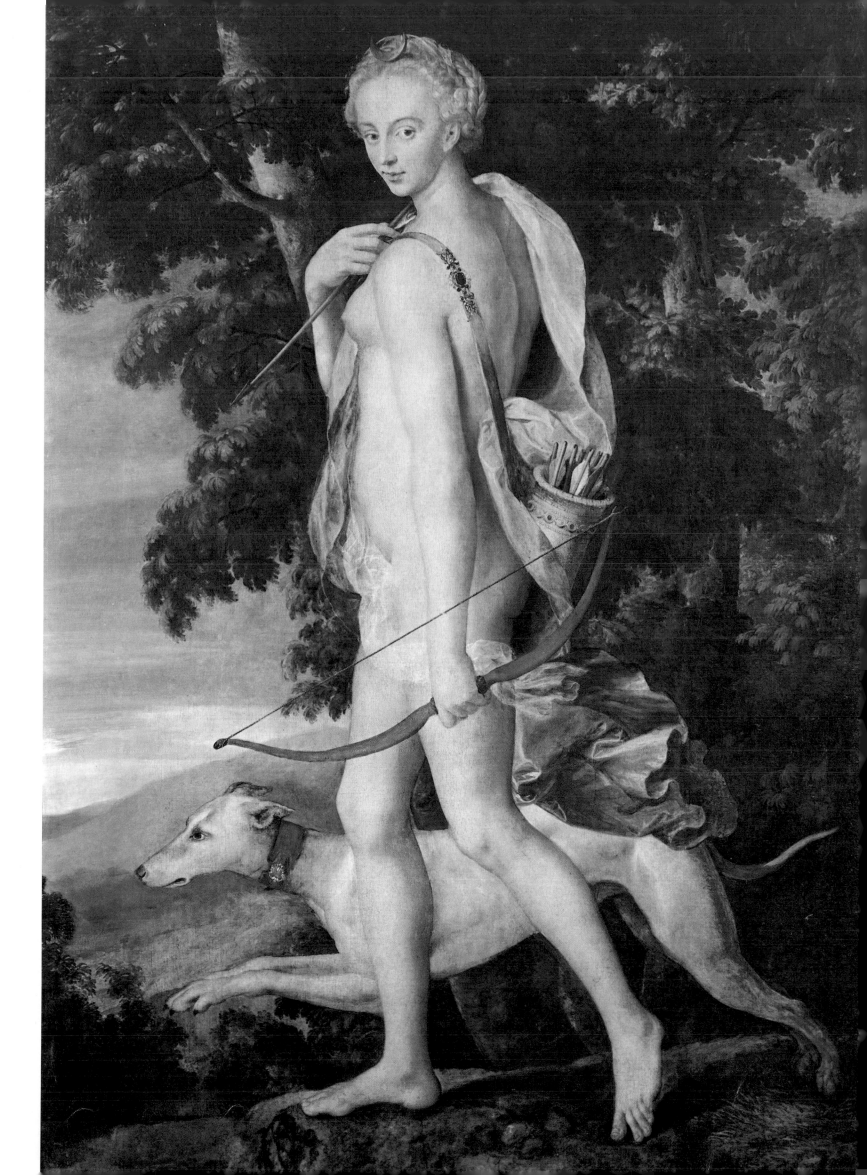

the Daughters of Leucippus, the artist has presented two female nudes in precisely complementary poses so that we are treated to good views of both breasts and buttocks. But the work is saved from mere licentiousness by the artist's extreme serious approach to mythology. Rubens was a most voracious classical scholar, and in his works he used nudes, in the same way as he used the most evocative landscape backgrounds, to translate scholarship into paint, to make an alien world of deities or complex allegories accessible to the man of ordinary sensibility. The powerful sense of conviction behind his interpretation of the classical world is a major reason why his nudes never seem, unlike their Mannerist counterparts, ridiculously out of place in their surroundings. Their complete naturalness and lack of inhibition in turn explains why they have never caused offence, other than a purely aesthetic one. At Ruben's death in 1640, only one person showed any embarrassment towards his work, and that was, not surprisingly, his second wife, Hélène Fourment. After Rubens married her in 1630 virtually all his subsequent nudes were variations of depicting her body. The relative absence of actual life drawing studies of the female nude makes one speculate as to how much he worked directly from the model. The vast majority of his naked figures were probably simply recollections of experience, as imaginative as his recreations of antiquity. The Prado *Three Graces* is one of the artist's most famous pictures devoted entirely to the female nude; such details as hands wallowing in flesh establish a corporal actuality which it would be hard to surpass, but no real bodies look quite like these. Without deceiving ourselves into believing that the seventeenth-century Flemish woman was a unique physiological specimen, the answer to our doubts is that, quite simply, Rubens' transformation of the body into a contour map of ridges and furrows goes beyond the straightforward depiction of real life to express an ideal of health and abundance. As such his nudes also go beyond pure eroticism.

The nude as a subject in itself was not contained, prior to the eighteenth century, within the sphere of mythological painting. In the case of religious art, however, it is generally

Giordano: *Tarquin and Lucretia*, 138 × 188cm

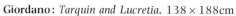

Rubens: *The Rape of the Daughters of Leucippus*, 222× 209cm, 1618

The painting portrays the twins Castor and Pollux seizing Phoebe and Hilaria, daughters of the priest Leucippus and engaged to Idas and Lynceus; the two betrothed men eventually pursued the brothers and killed them. Rape subjects were extremely popular in the seventeenth century and were opportunities to heighten sensuality through violence. Sometimes the results could be very crude, as in versions of the 'Tarquin and Lucrezia' story, in which a naked struggling girl is threatened at knife point. In Rubens' *Daughters*, however, violence is somewhat purified and the spectator more conscious of witnessing an impressive display of athletics. In spite of Rubens' classical erudition, the supposedly white horses of Castor and Pollux have changed colour to emphasize the shining skin of the heroines, but the work still remains deeply serious in tone. Nudity has been subjected to a formal beauty of composition, and the violence of the subject matter is subordinate to an almost abstract study of movement.

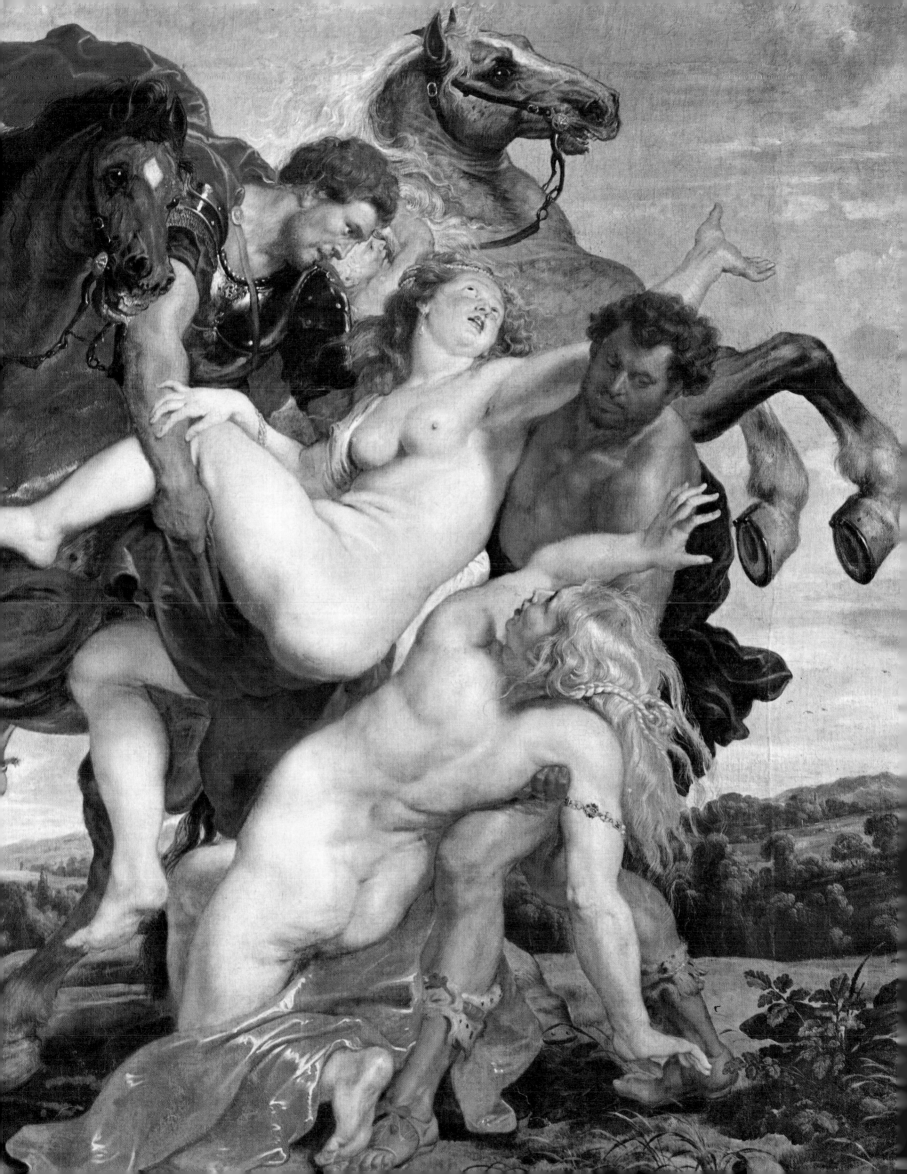

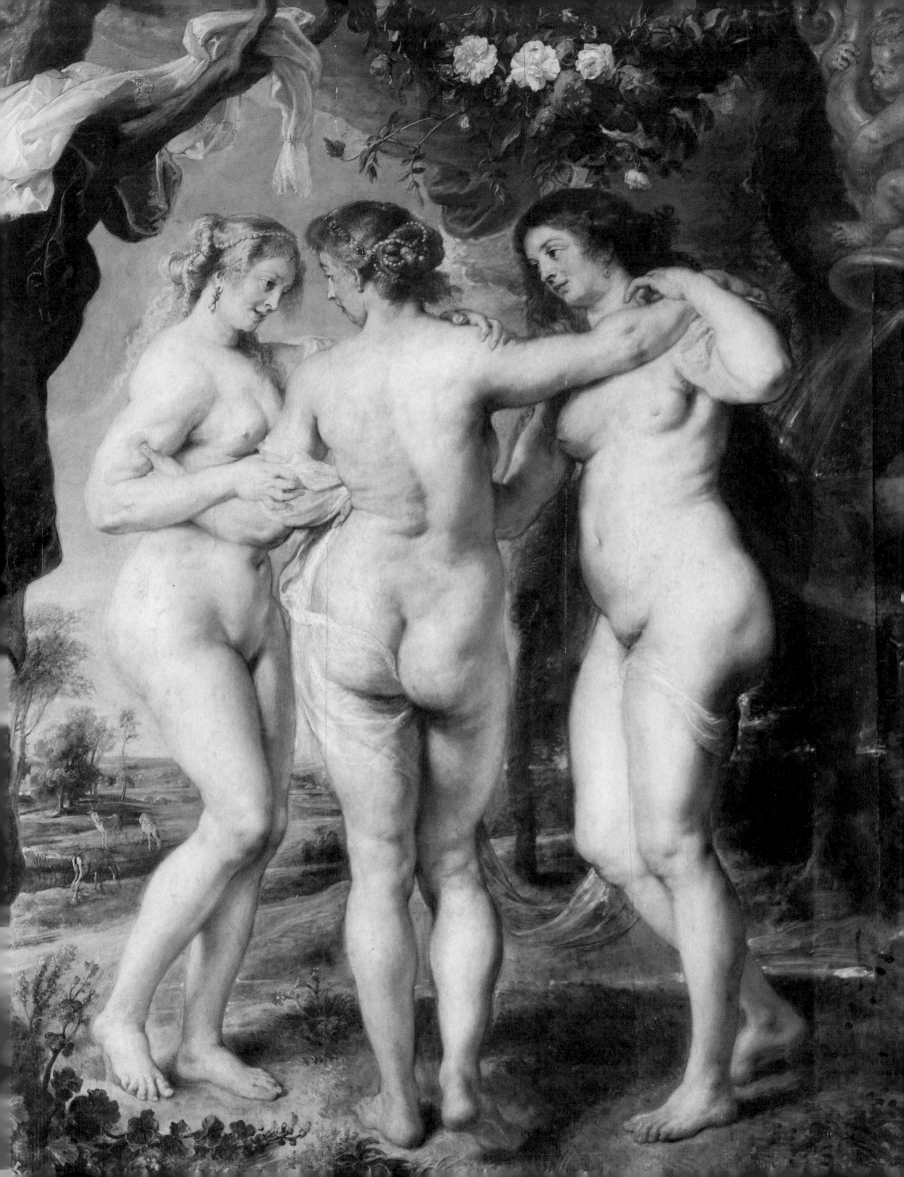

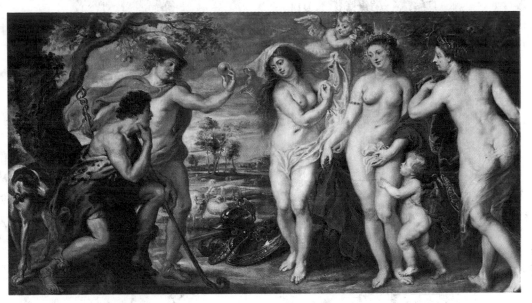

OPPOSITE **Rubens:** *The Three Graces*, 221 × 181cm, 1638–40

RIGHT **Rubens:** *The Judgement of Paris*, 199 × 379cm, 1638–9

not fair to discuss the innumerable male nudes who appear in crucifixions and martyrdoms, outside the more elevated context of their subject-matter. There have, of course, been exceptions. One of these is the subject of St. Jerome praying in the wilderness. From the time of Leonardo da Vinci onwards the saint's taut, emaciated body provided an excuse for pure anatomical study. Torrigiani's sculpture of the sub-

ject has been used since the Renaissance as an instrumental maquette for art students at the Seville Academy. The homosexual painter's interest in the naked male body should also be taken into account, for although the nudes of, for example, Michelangelo have a spiritual intention, the artist was also physically attracted by the original models. The subject of St. Sebastian is the most notorious example of a

Rubens: *Judgement of Paris*, 145 × 194cm, London

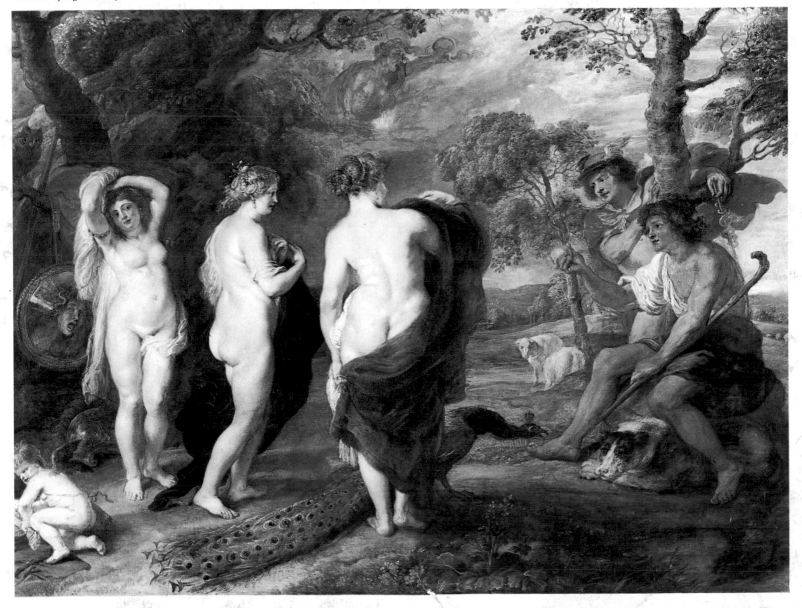

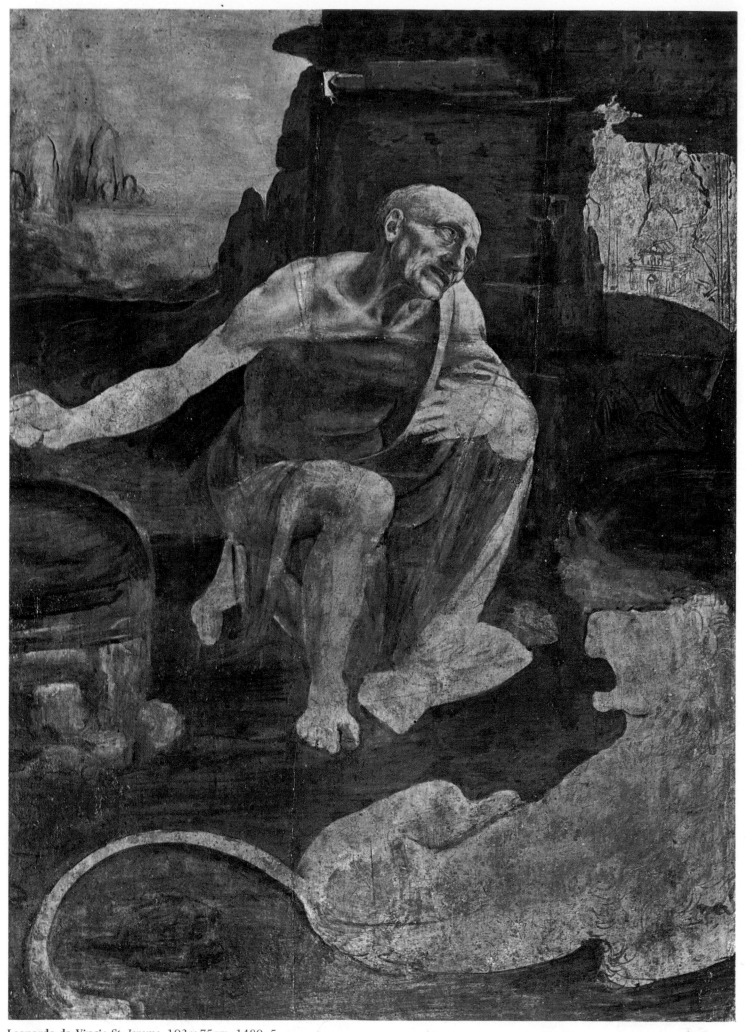

Leonardo da Vinci: *St. Jerome,* 103 × 75cm, 1480–5

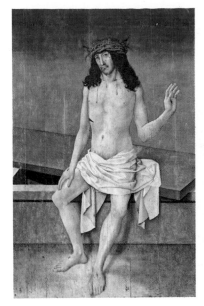

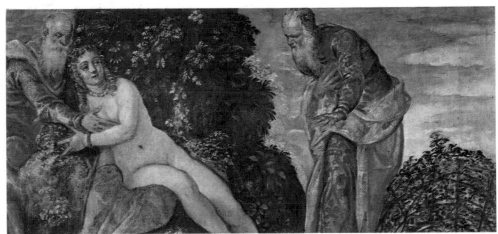

LEFT **Rueland Frueauf the Elder**: *Ecce Homo,* 183 × 116cm

BELOW **Tintoretto**: *Suzanna and the Elders,* 58 × 116cm, c.1560

sexually exploited religious subject; not only were there possibilities in the portrayal of a beautiful and defenceless body pierced by arrows, but also the deep concern with which St. Irene and her companions cured the wounds after the martydom had all the perverse overtones of morbid sexual fascination.

Only the Old Testament has furnished subjects where the female nude comes back into her own. The two subjects of Suzanna and the Elders and Bathsheba, hold very much the same place in religious art as the Song of Songs does in the Bible, and both were constantly used by artists right up to the nineteenth century. The theme of a young girl being

watched by a couple of frustrated old men combines both humour and voyeurism. Usually, artists showed the actual moment of Susannah's discovery, but Tintoretto's originality in the famous painting in Vienna, lay in choosing the preceding moment of contemplation. The artist's typically unusual composition places the head of one of the old men right in the bottom foreground of the painting, and we ourselves are compelled to identify with him, interrupting a young girl totally engrossed in the reflection of her body in a mirror. The mirror continues to be the inevitable accompaniment of an image of naked female beauty, but completely loses its connotations of *Vanitas*; in this case, surrounded by a still-life of comb, ring, pearls and other discarded objects, it plays an essential part in a mysterious feminine ritual which we are privileged to witness.

The story of Bathsheba also inspired one very arresting interpretation. Rembrandt's picture in the Louvre is certainly far removed in spirit from the habitually titillating versions of the subject. Representing his mistress, Hendrikje Stoffels, Rembrandt's work is more of a portrait than a depiction nude. The distinction must be made, for, like Dürer's self-portraits, we are not presented with nakedness as an object of beauty, but rather as the most direct and expressive

Rubens: *Suzanna and the Elders,* 94 × 76cm

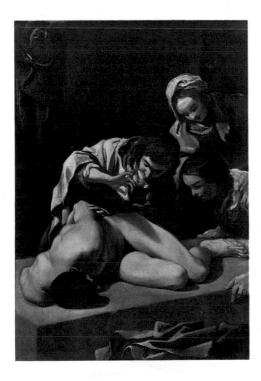

Schedoni: *St. Sebastian and St. Irene,* 188 × 126cm, c.1614

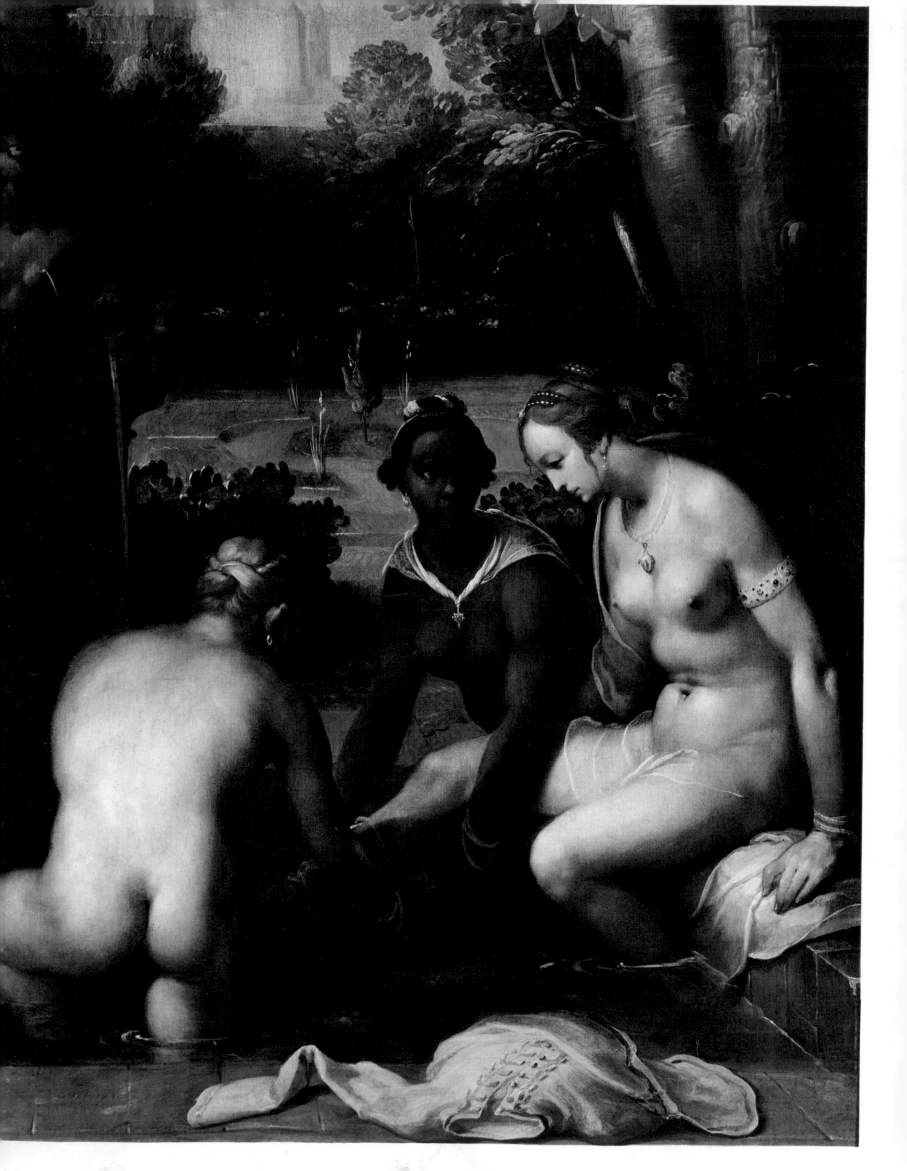

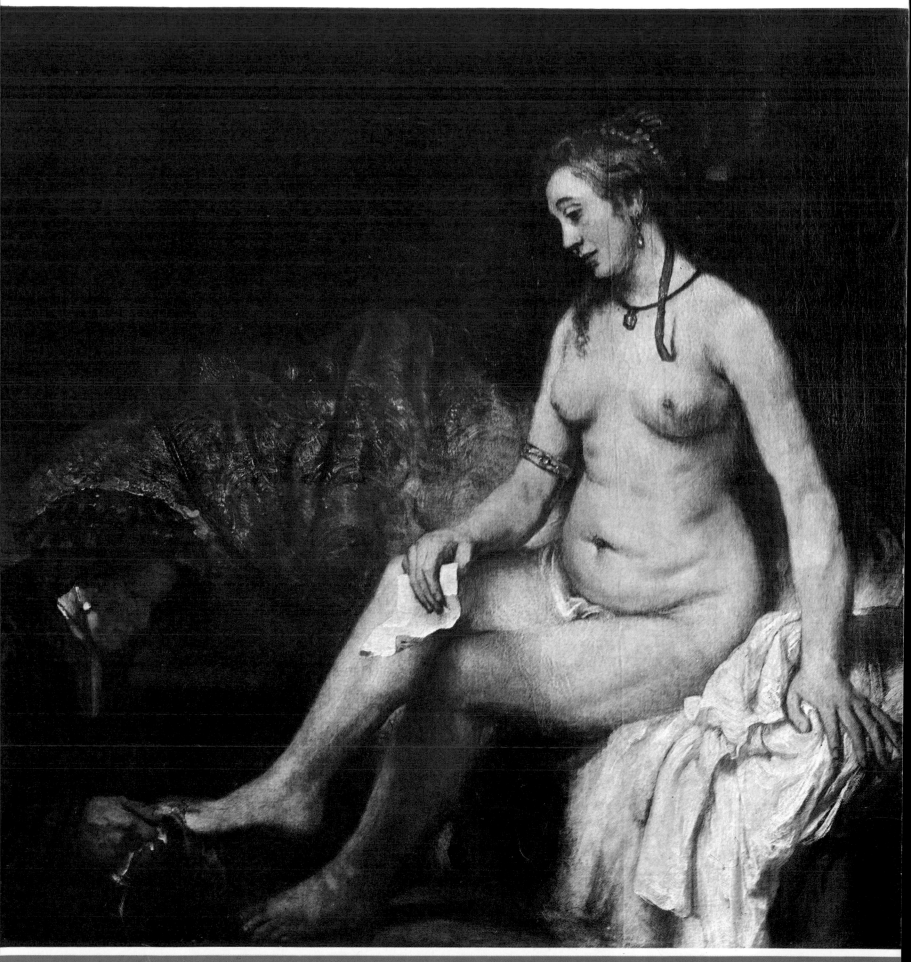

Rembrandt: *Bathsheba*, 142×142cm, 1654

The subject of Bathsheba had already been treated by
Rembrandt in a painting of 1643 now in New York; the earlier
version, in which the nude was much smaller in relation to its
surroundings, was, by its emphasis on the purely superficial
elements of the story, more typical of normal representations
of the subject. In the later version, the addition of David's
letter in her hand and the pensive pose of her face (arrived at,
as X-rays show, after many trials), looking down, instead of
towards the spectator, radically alters the mood; moreover the

OPPOSITE **Cornelius van Haarlem:** *Bathsheba*, 77·5 × 64cm

deep concentration of both Bethsheba and her old maid-
servant is now echoed in the starkly economical and relief-like
composition, typical of the mature Rembrandt. The model was
Hendrikje Stoffels, with whom the artist lived from about
1645, and who was described by a contemporary biographer,
Houbraken, as a 'peasant woman from Roorep, or Ruisdorp,
in the district of Waterland, small in figure but well-shaped of
face and plump of body'. The *Bathsheba* along with his *Diana*
of 1634, were Rembrandt's major painted nudes. One can
understand the excitement it caused when it was first
exhibited in the Louvre in 1869 to a public which had
recently come to admire Courbet's realistic handling of flesh.

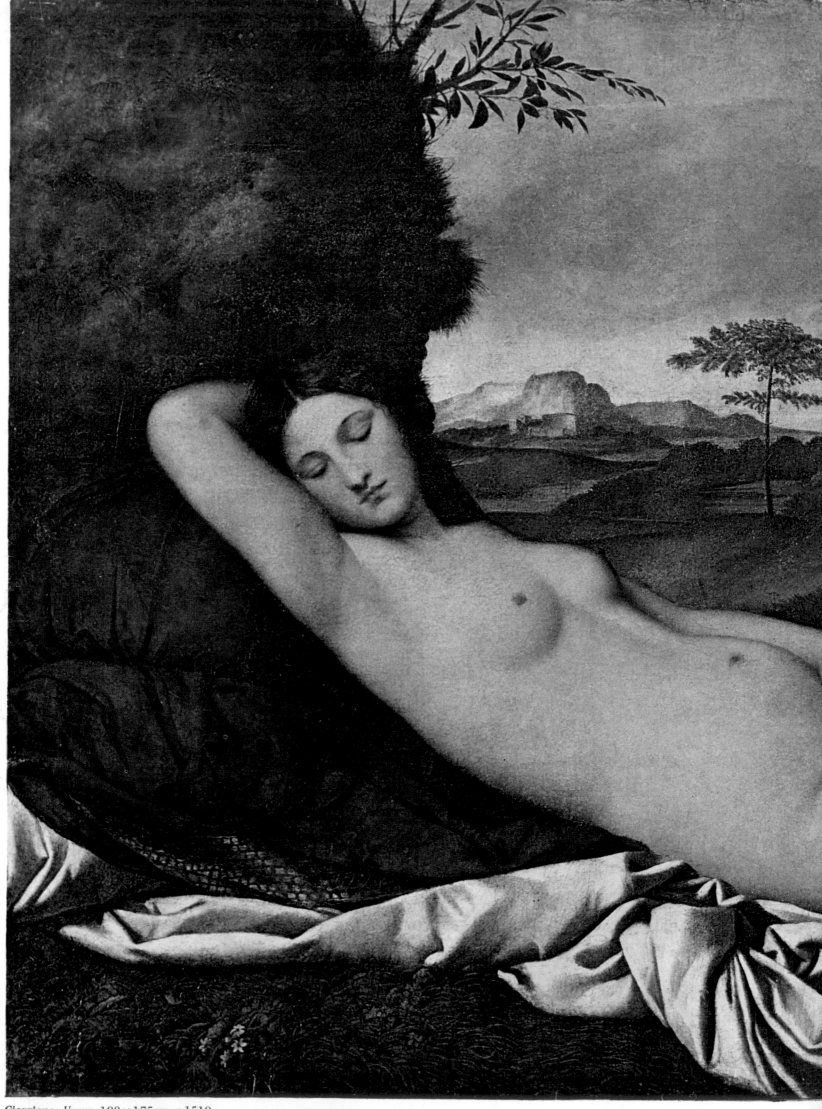

Giorgione: *Venus*, 108×175cm, c.1510

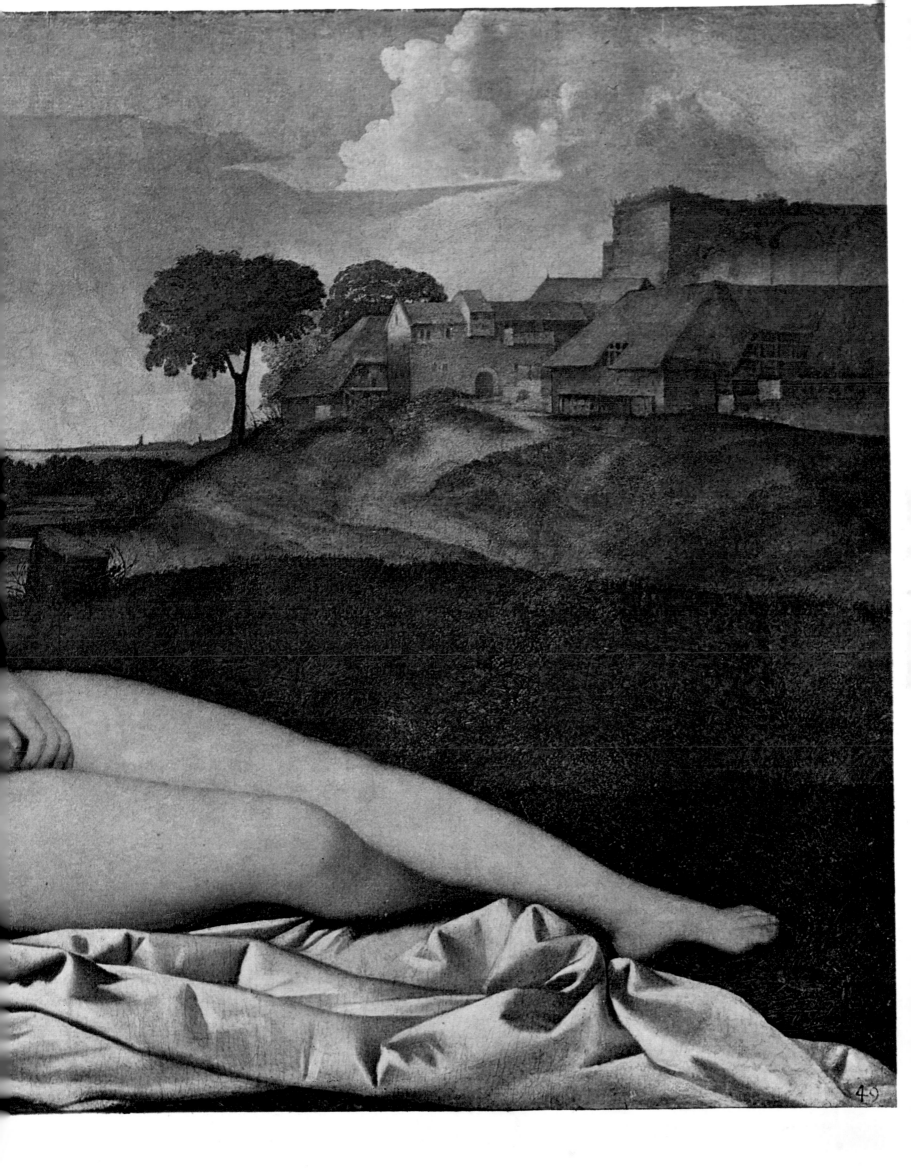

representation of depths of feeling. For once, an artist has created a sad pensive mood actually appropriate to the subject it depicts.

In its lack of insistence on the beauty of the body, Rembrandt's *Bathsheba* is also exceptional in the context of the single female nude, a category in art which can be most closely related to our contemporary 'pin-ups'. With these nudes not only does the disguise of meaning become negligible (the ubiquitous designation of 'Venus'), but sometimes disappears altogether. The first of these single figures is Giorgione's Dresden *Venus*. So accustomed are we now to countless variations of this obvious type of nude, that it is difficult to conceive the impact of what was probably the first, recumbent, female figure in the history of art. Historians have been worried by the lack of classical prototype for a figure of sleeping Venus, claiming that Giorgione must have been inspired by the very popular and much copied Roman statue of a sleeping Ariadne. If, in fact, classical justification is required for this type of figure it is provided by the fact that one of the three signed works by the greatest painter of antiquity, Apelles, was of exactly the same subject as Giorgione's painting. Whether Giorgione was consciously

recreating a classical composition, or whether he was sufficiently unimaginative to require an actual sculpture for inspiration is, of course, another matter. One thing is clear, that even if intended as a straightforward painting of a naked woman, the artist has felt compelled to disguise her as a Venus, and to make this quite clear the original canvas, before being damaged, showed a Cupid by her side.

The Dresden picture encapsulated all the qualities which later became characteristic of this type of pure sensual painting; a relaxed pose, a peaceful, undistracting setting, and a complete absence of narrative content. Titian, who completed the picture, was so impressed by Giorgione's figure, that he included an almost exact replica of her in his *Pardo Venus*. In a later work of his, of 1535, he went even further

Hayez: *Bathsheba*, 77 × 107cm, 1834

This is a later example, by the nineteenth-century Milanese artist, Hayez, of the typically debased treatment of the biblical subject; in this case even the accompanying maid-servant is portrayed with no clothes on.

LEFT **Hayez:** *Bathsheba* (detail)

than Giorgione by dispensing altogether with any classical disguise. The first reference to this work, which only at a much later date became known as the *Venus of Urbino*, is found in a letter of 1538 of Guidobaldo della Rovere, soon to become Duke of Urbino, in which he urged his Venetian agent, Leonardi, to procure for him Titian's painting of 'la donna nuda' (the naked lady). The naked lady in question, unaccompanied by any Cupid or classical paraphernalia, simply lies on a couch in a contemporary interior. Few other famous paintings of the past have such obvious claims as straightforward 'pin-ups', and yet inevitably scholars have hunted for hidden meanings; is, for instance, the dog who sits at her feet, symbolic of fidelity, and, if so, does this mean that Venus is shown in the guise of marital love? An equally futile speculation, one particularly associated with this category of nude

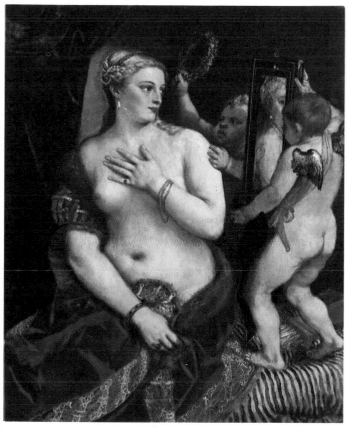

Titian: *Venus with a Mirror*, 124·5 × 105·5cm, 1552–5

painting, has been the identification of the model. The fact that the painting entered the Duke of Urbino's collection three years after it was completed would seem to rule out the possibility of his wife, Eleonora Gonzaga, posing for it, but gullible tourists to the Uffizi are still subjected to this wild nineteenth-century fancy, for nothing increases the erotic value of a naked figure more than putting a name to it, especially if one has a knowledge of what the person looks like fully clothed.

Giorgione and Titian's achievement in making a picture of the nude enjoyable in itself may have prompted a much older Venetian painter, Bellini, to attempt the same. Bellini's *Woman at her Toilet* is dated 1515, when the artist was seventy-five, and is probably the work, referred to by Vasari, which depicted the mistress of the humanist, Pietro Bembo. The painting is the first example of a type of subject in which,

as in Tintoretto's *Susannah*, the medieval mirror of Vanity is transformed into a boudoir adornment. The most copied version of this subject in the sixteenth century was Titian's picture of c.1552–5. Titian painted a later variation, replacing the completely naked figure with a partially draped one. This work was shipped to Phillip II of Spain in 1567. It has been suggested that Titian might have added the drapery in view of the king's increasingly notorious religious obsessions, but this suggestion is put in its right place by the eighteenth-century traveller, Richard Cumberland, who describes the Venus figure as of 'wanton cast . . . half concealed, with such studied negligence of dress, and so much playfulness of expression and attitude, that the draperies seem introduced for no other purpose but to attract more strongly to the charms they do not serve to hide'.

Outside Italy the most prolific and bizarre portrayer of the 'pin-up' nude, was the immensely successful court painter in

Pages 44–5. **Titian:** *Venus of Urbino,* 119 × 165cm, 1536

As is made quite clear by the first reference to the work in 1536, the painting simply represents a naked woman in a contemporary interior; in this the work is a development on the Giorgone *Venus* which inspired it, and the addition of the bracelet and hair-clip doubly increases our awareness of nakedness and contemporaneity. These adornments are the features of the Renaissance nude which most obviously transform classical prototype into a modern 'pin-up'; Manet brilliantly parodied them in his *Olympia*, but went even further by the inclusion of a dangling slipper. Titian's work belongs to a period in his art (the 1530s) in which the habitually dynamic quality of his compositions is replaced by a greater impassivity. The fresh simplicity of the painting, and its concentration on colour, must have doubled its attractiveness for the nineteenth century.

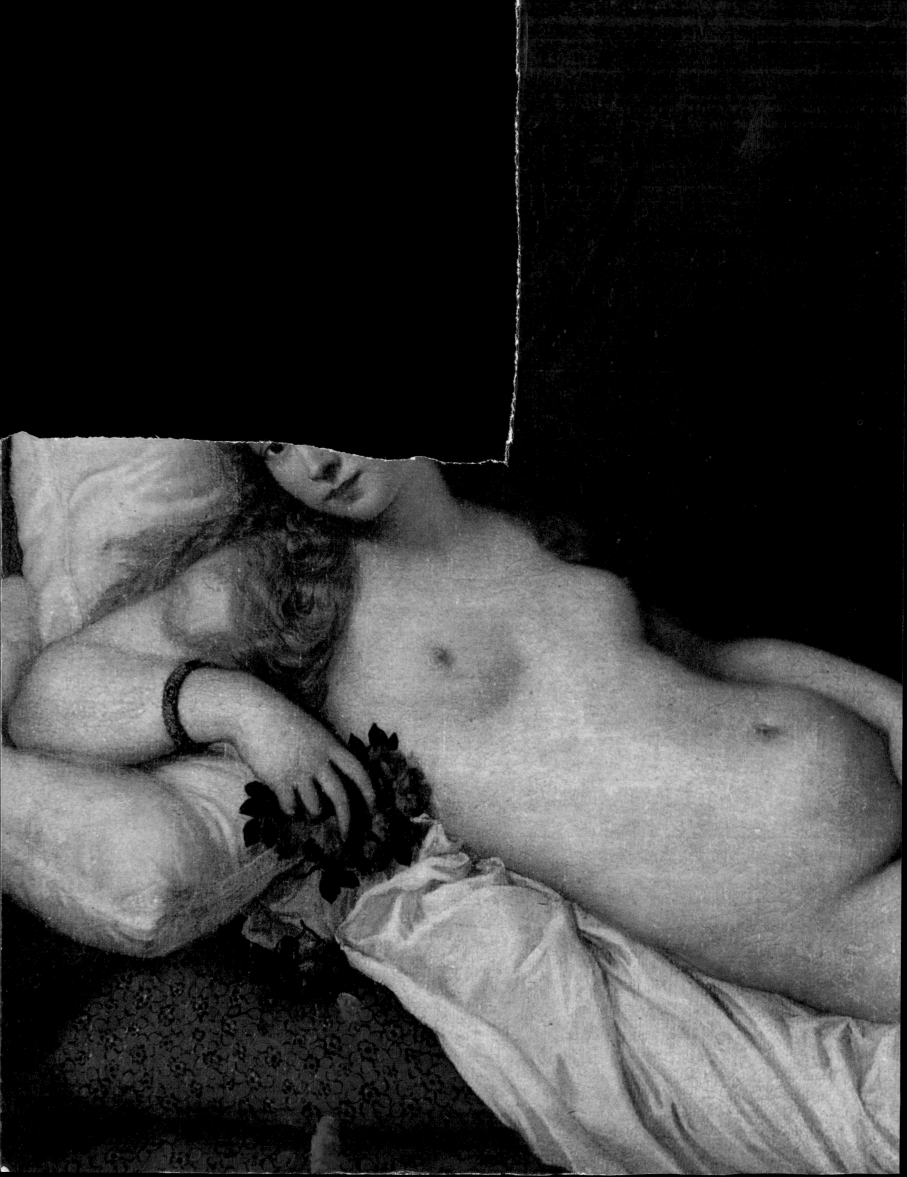

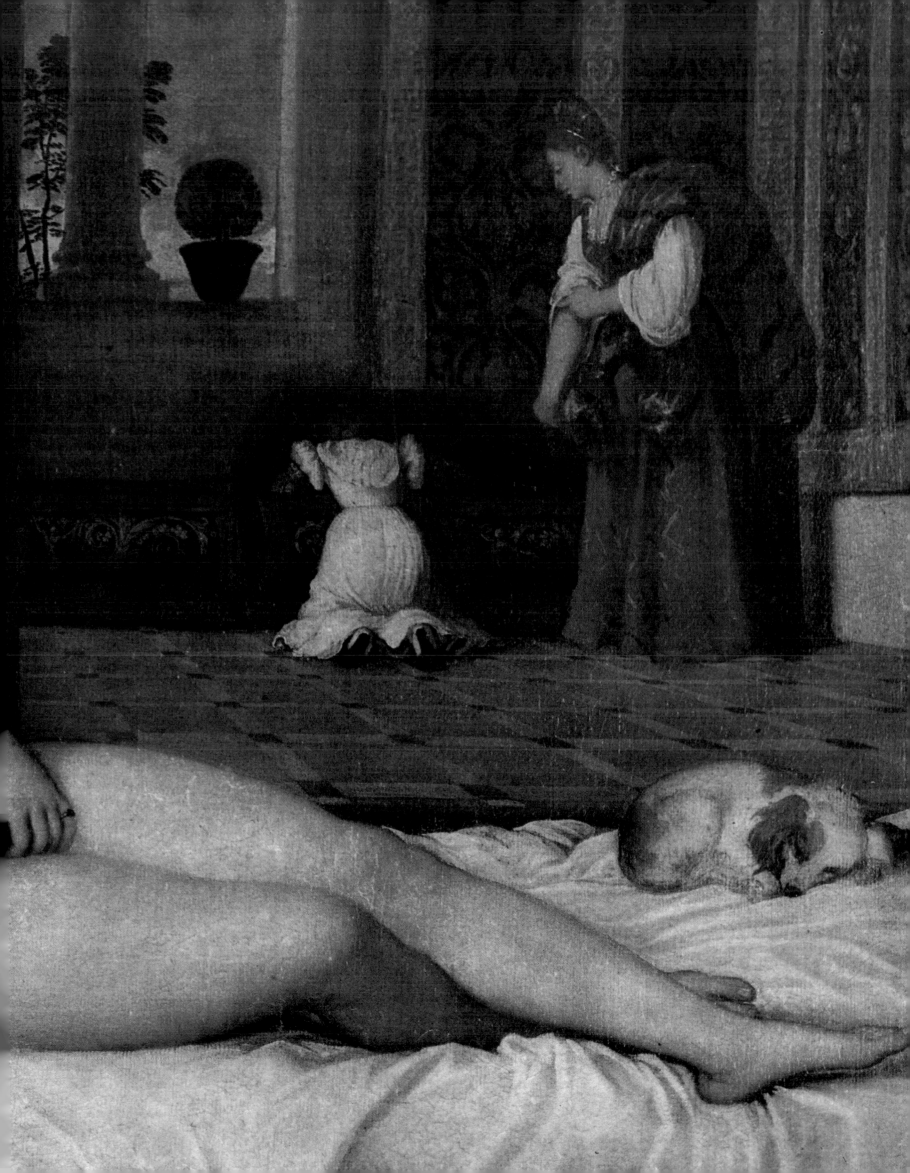

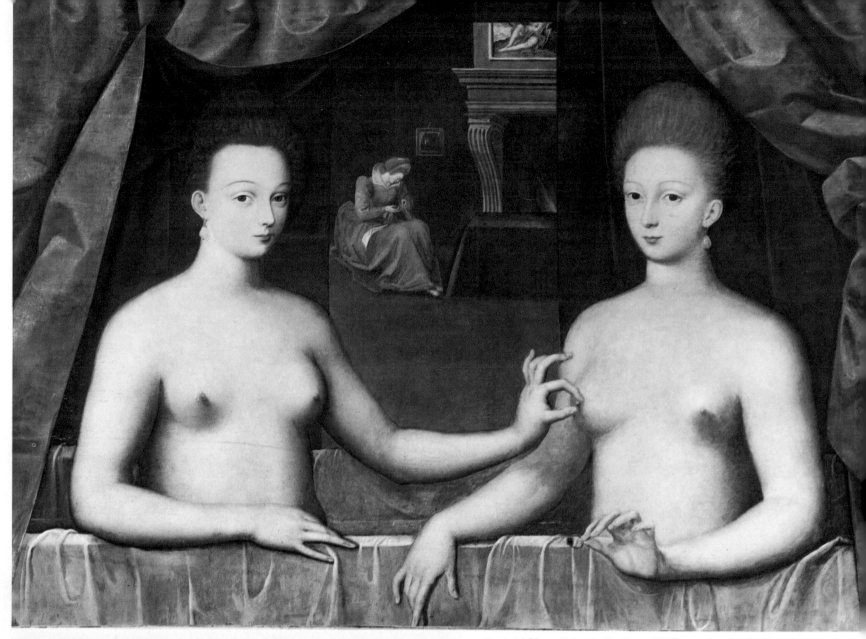

Fontainebleau School: *Duchess of Villars and Gabrielle d'Estrées at their Bath*, 96 × 125cm, c.1594

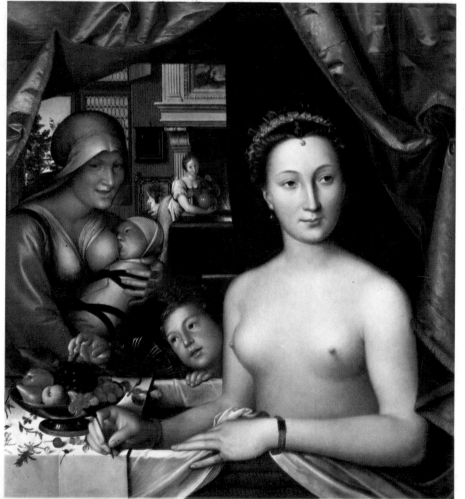

the Bavarian state of Wittemberg, Lucas Cranach. Cranach's *Reclining Nymph*, which exists in many versions, is like a primitive *Dresden Venus*. However, in spite of the remarkable likeness of the pose, the German artist could not possibly have known Giorgione's work, and, with the exception of a possible encounter with Titian when he visited Augsburg in 1650, there are no other direct connections with Italian art. What were probably simple notions of the new Italianate ideal of beauty, were, at any rate, imbued with a thoroughly Germanic spirit. Cranach's nudes, generally outlined against a black background, combine lithe elegant bodies with surprisingly coarse and nordic facial features. They are women supremely aware of their ability to tantalize, self-consciously posed, bedecked with jewellery in spite of their nakedness,

Clouet: *'Diane de Poitiers'*, 92·1 × 81·3cm, c.1570

Well-known beauties of the Renaissance were frequently depicted in a semi-naked state but nowhere was the tradition more prevalent than in the French Court. This picture, traditionally said to be of Diane de Poitiers, but more likely to be of Marie Touclet, the mistress of Charles V, had the similar function of sex symbol as the twentieth-century images of Marilyn Monroe or Brigitte Bardot.

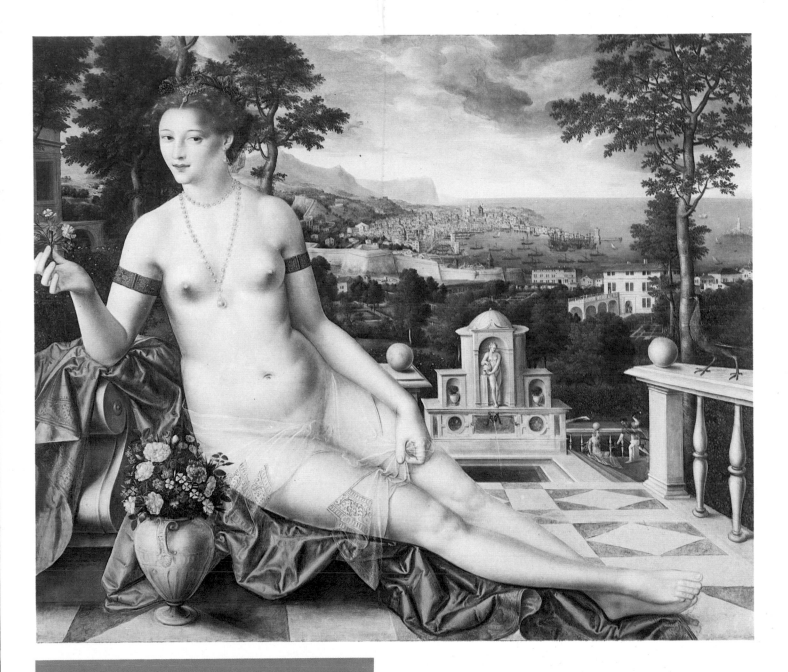

Metsys: *Flora*, 130×156cm

The degree of acceptance which the nude had acquired in Italy must have inspired, in the eyes of foreigners, visions of a hedonistic paradise. Metsys, in a way typical of much pornography today, places a naked figure against a sunlit background (the Bay of Naples), which in itself would have seemed an exotic novelty for most of his northern patrons.

Cranach: *Reclining Nymph*, 48·5 × 80cm, 1530–5

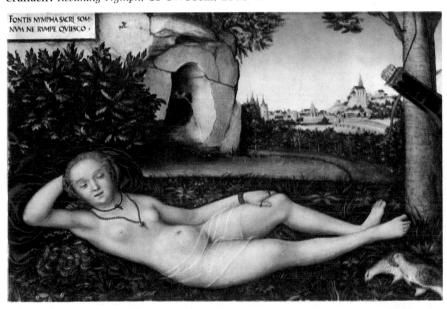

futilely attempting to cover themselves with the flimsiest pieces of transparent drapery. In their guise of temptresses they hark back to the medieval nude, only this time the overtones of temptation have purposely increased the charms of the subject. It was perhaps for this suggestion of sin and evil that Luther, who described Cranach as a 'crude painter' should have wanted the artist to have been 'less hard on the female sex both because they are God's creatures and because they are our mothers'.

Another artist with a line of blatant 'pin-ups' was Caravaggio, but his sexual inclinations, like those of his clientele, were exclusively homosexual. The male nude in art, usually

45

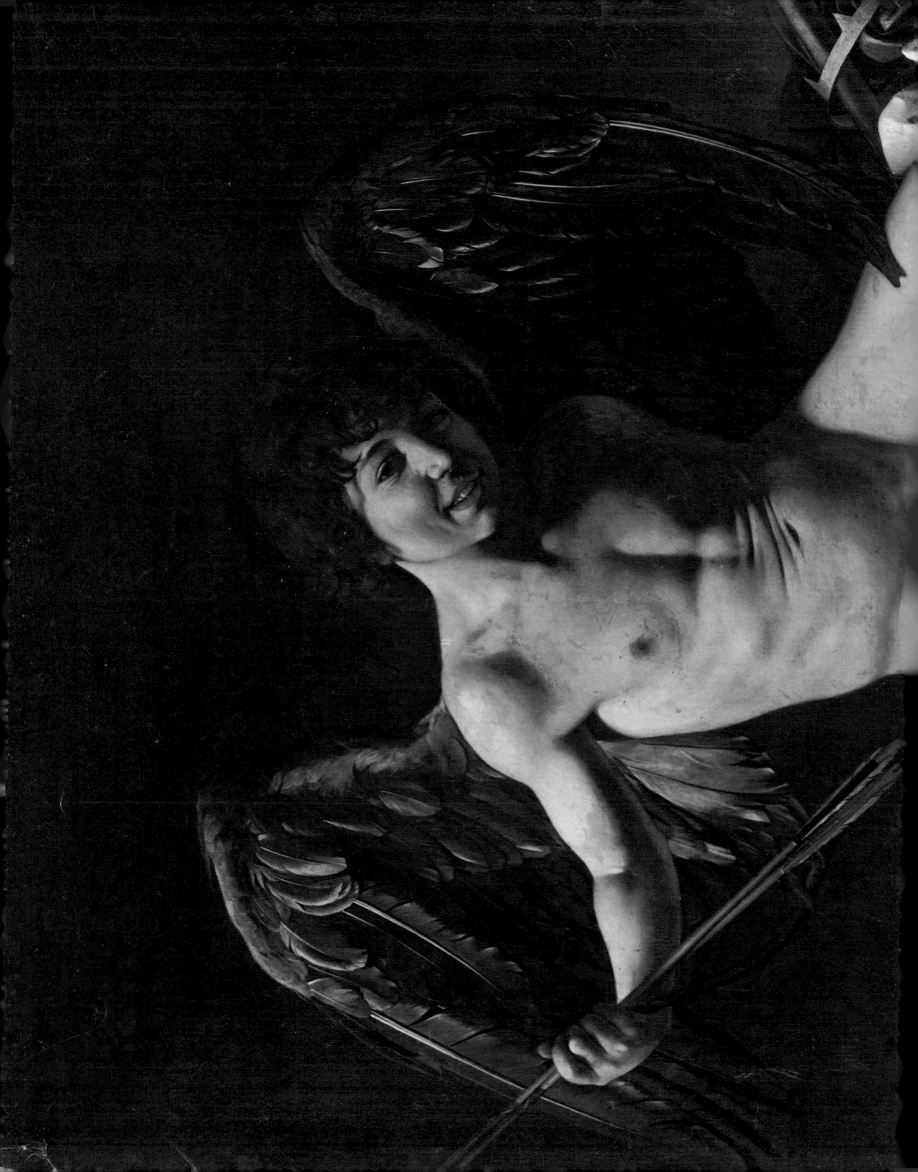

Pages 46-7. **Caravaggio:** *Victorious Amor,*
154×110cm. c.1600-3

Caravaggio's first years on arrival in Rome in about
1590 were unsuccessful until he was discovered, some
time in the middle of the decade, by the influential
Cardinal del Monte, to whom the artist's exclusive
concentration, at the time, on pictures of attractive,

sometimes semi-naked, young boys had immense
appeal. Even when, through the intercession of the
Cardinal, Caravaggio was given the commission to
decorate a chapel in San Luigi dei Francesi, these
youths still made an appearance, this time playing
cards with an elderly man. Some of the artist's most
erotic paintings are indeed, like the *St. John the*

Baptist in the Wilderness, once in the collection of
Cardinal Pio, nude 'pin-ups' masquerading as religious
works. The great popularity of a painting like the
Victorious Amor – so great the artist was allowed to go
free after being arrested in a libel suit – is evidence of
how large the market in child pornography was, and
how successfully Caravaggio had cornered it.

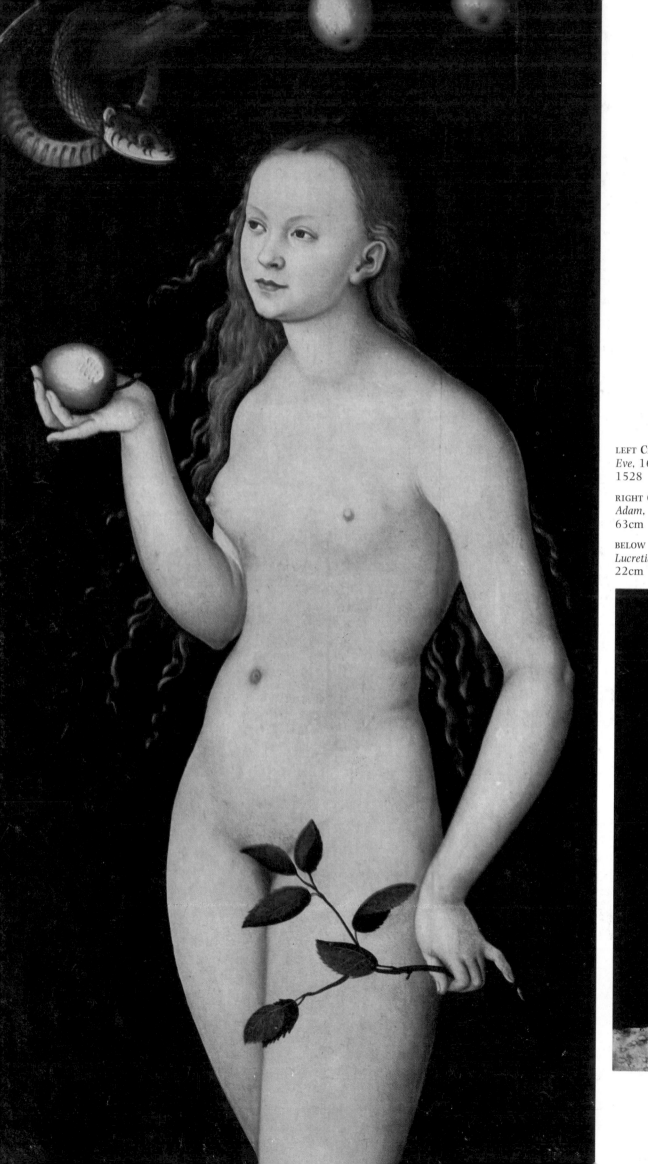

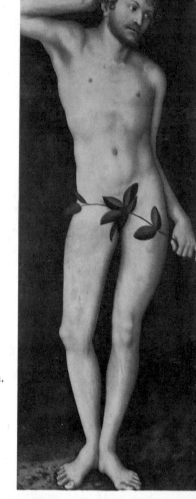

LEFT **Cranach**:
Eve, 167 × 61cm,
1528

RIGHT **Cranach**:
Adam, 172 ×
63cm

BELOW **Cranach**:
Lucretia, 36 ×
22cm

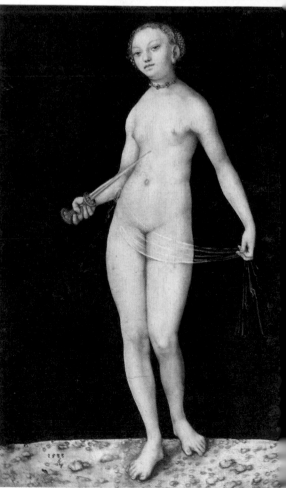

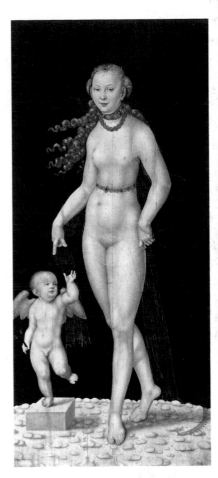

Cranach: *Venus and Cupid*, 170×73cm, 1531

athletic and well-developed, seems absurd as simply a languorous object of passive sensual contemplation. Exceptions are the bodies of young boys, which served as subjects for many of Caravaggio's early paintings, destined for such notorious paedophiliacs as Cardinal del Monte and Vincenzo Giustiniani. The latter owned the Berlin *Victorious Amor*, a work which, in spite of the token allegorical symbols, is straightforward in its intentions. The provocative and teasing pose of the boy both gives full emphasis to the penis, right at the centre of the composition, and also enables an unusual glimpse of buttocks. The habitual realism of the artist strengthens the figure's shocking physical presence. The German painter and writer on art, Sandrart, advised Giustiniani to cover this work with a curtain, giving as his reason that it was so outstanding a painting that it would outshine all others in his collection. This far-fetched reasoning hides the fact that by covering the work, the owner was simply following a practice reserved for the female nude. As in Titian's partially draped Venus, the act of covering only drew attention to the eroticism.

The frequent use of a curtain in the history of nude painting highlights the very private nature of so many of the great nudes of the past; they were accessible only to the privileged few, sometimes to just the close circle of the artist himself. Of the latter type was Ruben's 'Het Pelske', an intimate portrait of Hélène Fourment which remained in the artist's studio until his death and was one of the nudes which his widow was, understandably, reluctant to part with. As purely a private record of an artist's obsession with his wife's body, it is difficult to imagine how the work could pose any problems of interpretation. Yet again this is far from being the case. Apart from the usual considerations of whether the

figure is a Venus or not, many have pondered over the significance of her standing naked with just a fur coat. Art historians have been strongly divided over whether she is coming from or going to a bath, but few have been so ingenious as the pioneering Rubens scholar, Gluck: 'During a pause in between modelling, Hélène may have wrapped herself in a fur coat in order to get warm. This may have aroused in Rubens a recollection of . . . Titian's girl in a fur coat, now also in the Vienna Gallery.' The most obvious reason for the fur coat is surely to heighten the work's sensuality, in the same way that the *Venus Pudica* gesture, usually intended as a modest shield of nakedness, only serves to give added prominence to the breasts.

A good deal of secrecy must have shrouded Velasquez's *Rokeby Venus*, one of the only non-royal commissions of the artist's Madrid years, and a female nude, like Goya's *Maja Desnuda*, totally exceptional in the prudish context of Spain. This is ironical, as the Spanish Court had acquired some of the most sensuous mythological paintings of the Renaissance, including Titian's *Bacchanal of the Andrians* and *Danaë*, and, at one stage, Correggio's *Leda* and *Io*. Such works as these did not even prompt a native mythological tradition, and thus the respectable status of Venus given to Velasquez's naked woman by the addition of a cupid and mirror (which, on technical evidence, seem probable after-thoughts) could not have tempered the painting's impact and unusualness. The first reference to the work is in a 1651 inventory of the

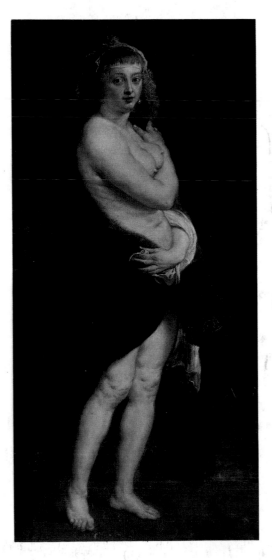

Rubens: *Hélène Fourment ('Het Pelske')*, 176× 83cm, c.1635

Velazquez:
Rokeby Venus.

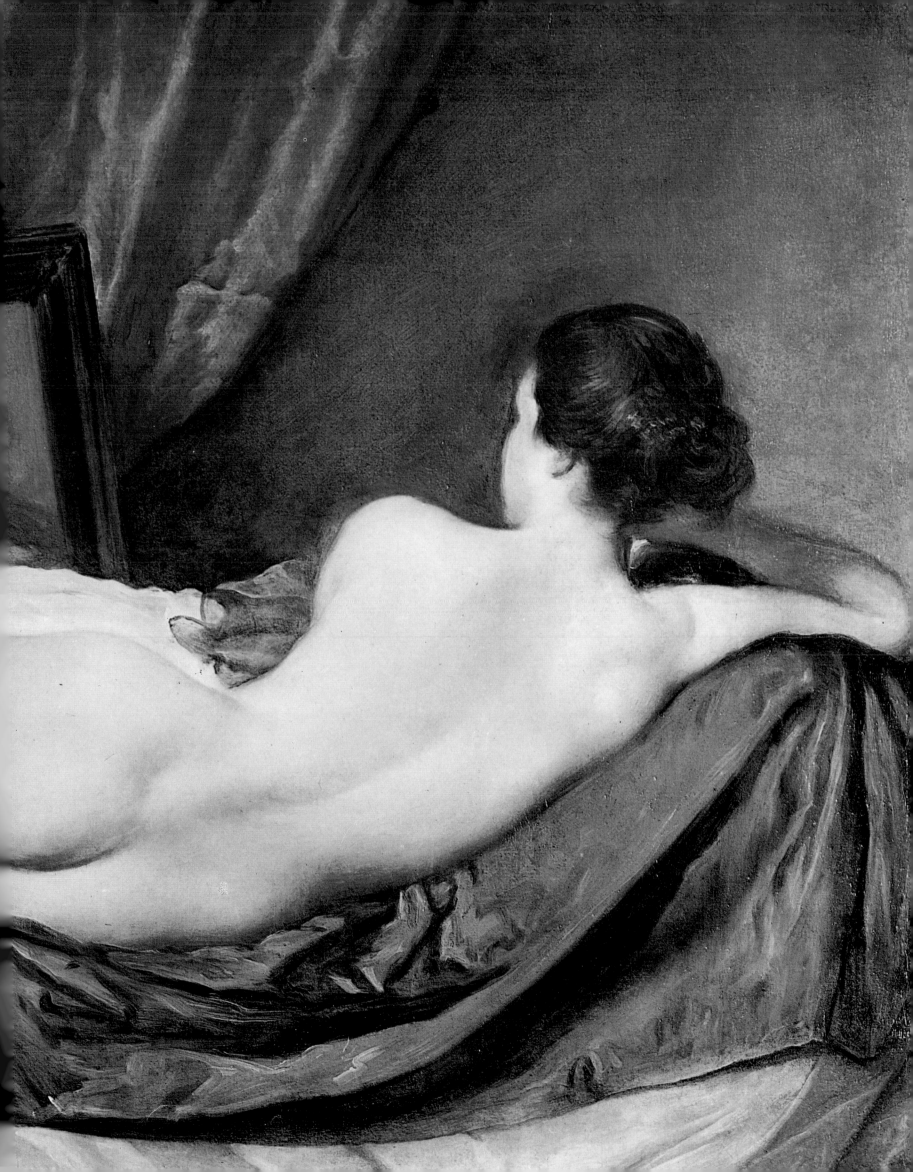

Pages 52–3. **Velazquez:** *Rokeby Venus,*
122·5 × 177cm, c.1650

In the same way as *Maja Desnuda* was important for Goya, this nude was exceptional in Velazquez's work. The attitude towards the nude in Spain was severer than in any other European country; the Spanish Art Academy, for instance, was the last in Europe even to allow male models. The *Rokeby Venus,* one of the artist's few non-royal commissions of his Madrid years, might have been painted at the beginning of the artist's second Italian visit (1650–3), inspired by the more liberal and hedonistic atmosphere of that country. All Velazquez's mythological paintings show a remarkable inventiveness, reinterpreting classical subject-matter in a way which brilliantly makes classical legend come alive; in the case of the *Venus,* where the classical disguise is negligible, the impact on the artist's Spanish contemporaries must have been even more stunning, for not only is the realism in the handling of a naked figure virtually unprecedented in art, but so is the depiction of the nude seen from the back. In the nine-teenth century, when the painting was in Rokeby Hall, Yorkshire, it was hung high above the chimney-piece so that by 'raising the said backside to a considerable height, the ladies may avert their downcast eyes without difficulty, and connoisseurs steal a glance without drawing the said posterior into the company'.

collection of the Marquis of Eliche in which it is unashamedly described as a 'painting on canvas of a naked woman . . . looking at a mirror held by a child'. Seen simply in these terms the work shows how, by the simplest means, the slightest suggestion of modelling, the artist has created a figure of uncanny presence, a verisimilitude of flesh which not even Titian could equal. The recumbent nude seen from the back is also, like everything to do with Velasquez's art, a strikingly fresh conception. As a pose of such obvious sim-plistic power, it would not, however, have been beyond the imagination of an artist of his calibre, yet art historians have thought differently, suggesting sources which have ranged from figures from the Sistine ceiling to an engraving by Phillip Galle after Antonie von Blocklandt. The face in the

Boucher: *Rest of Diana,* 57 × 73cm, 1742

This unashamedly erotic representation of classical story is summarized in the way in which a string of pearls is used to highlight the translucence of flesh. In such a coyly precious world, Actaeon, who was trans-formed into a stag while watching Diana bathing, would seem totally out of place.

RIGHT **Boucher:** *The Rest of Diana* (detail)

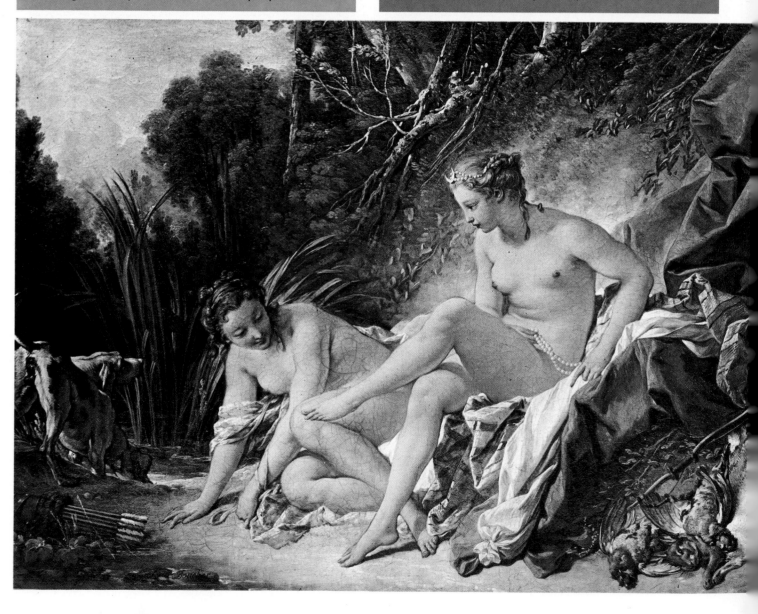

mirror has also caused scholarly headaches, not just connected with identification of the model, but with the fact (and this has been proved by a recent photographic reconstruction of the composition) that the mirror would reflect a much lower part of the woman's body.

At the end of the eighteenth century the *Rokeby Venus* was in the possession of the Duchess of Alba. This woman, described in a contemporary poem as the 'Spanish Venus', has been popularly regarded as the most likely candidate for the model of Goya's *Maja Desnuda*. For once such identification has a basis in fact. The intimate relationship between the artist and the Duchess is well known, but, more importantly, there survives a book of sketches made while Goya was staying with her in her villa at Sanlucar de Barrameda in Andalusia, immediately after the sudden death of her husband on 9 June 1796. Included in this book are a number of representations of the Duchess (testified as such by an early source) as well as various crude sketches of female nudes. Not only does it seem likely that she posed for the latter, but also that these in turn inspired the *Maja Desnuda*, a work, in which, for obvious reasons, the face of the Duchess had to be disguised. There is also the possibility that this work might have actually hung in her house. Although the painting is first known in the collection of the Court favourite, Godoy, the latter had, in the previous year, instigated a violent embargo of the Duchess' possessions, including the *Rokeby Venus*; it would seem very plausible that the Goya had been

acquired in the same coup. At all events, the two greatest Spanish nudes hung at one stage together in Godoy's collection, and they must have appeared as perfectly complementary, providing, for those frustrated with just the back view of Velasquez, a blatant full-frontal with an innovatory depiction of pubic hair. Another problem, besides that of provenance, is presented by an identically posed version of Goya's figure, the *Maja*, this time fully dressed. The existence of such a pair is a novelty in art, and is generally explained by the assumption that in Godoy's collection, this clothed version covered the naked one, the latter being revealed by simply moving a lever. If true, and it would be in character with Godoy's dubious taste in art, the mechanics of pornography have triumphed over art. This cover, along with the disguise as Venuses (which they most clearly are not) was not sufficient to prevent Goya, in 1815, from being denounced to the Inquisition for being the author of two obscene paintings in Godoy's collection, one 'representing a naked woman on a bed . . . and the other dressed as a Maya on a bed'. Goya was asked to 'identify them and to declare if they are his works, for what reason he painted them, by whom they were commissioned and what were his intentions'. His declaration, which would have dispelled all the mystery surrounding the two works, has unfortunately never been discovered.

Not even the slightest mystery infects Boucher's portrait of *Mademoiselle Murphy*; the contemporary boudoir setting, the purposely sexy and unclassical pose of the figure, and the

Boucher: *Mademoiselle Murphy*, 59× 73cm, 1751

A German pupil of Boucher, Mannlich, recorded his master's own description of his ideal nude woman: 'We must not think of a woman's body as a covering for bones; it should not be fat though it should be firm and slender without thereby appearing to be thin.' These criteria for Boucher's ideal, closer in spirit to those of today's 'Playgirl of the Month' than to pure academic speculation, were met by Mademoiselle Murphy, one of the few models of the time who have not remained anonymous. Louison Murphy, a girl of Irish origin and brought up in poverty, became a model in 1751, the year of Boucher's painting; two years later, at the age of sixteen, she became mistress to Louis XV, who had been delighted by the naivety of her replies. Casanova saw her in 1752 in the state in which Boucher portrayed her and was greatly excited by her beauty: 'White like a lily, she had all the beauty that both nature and the painter's art could possibly bestow on someone.' Boucher's *Mademoiselle Murphy* was scathingly referred to by Diderot in a review of the *Salon* of 1767, as an example of an indecent painting which was acceptable because the subject was so attractive. His apparent delight in describing the work seems nonetheless to belie his moralizing stand-point: 'A completely naked woman stretched out on pillows, legs astride, offering the most voluptuous head, the most beautiful back, the finest buttocks. . . .'

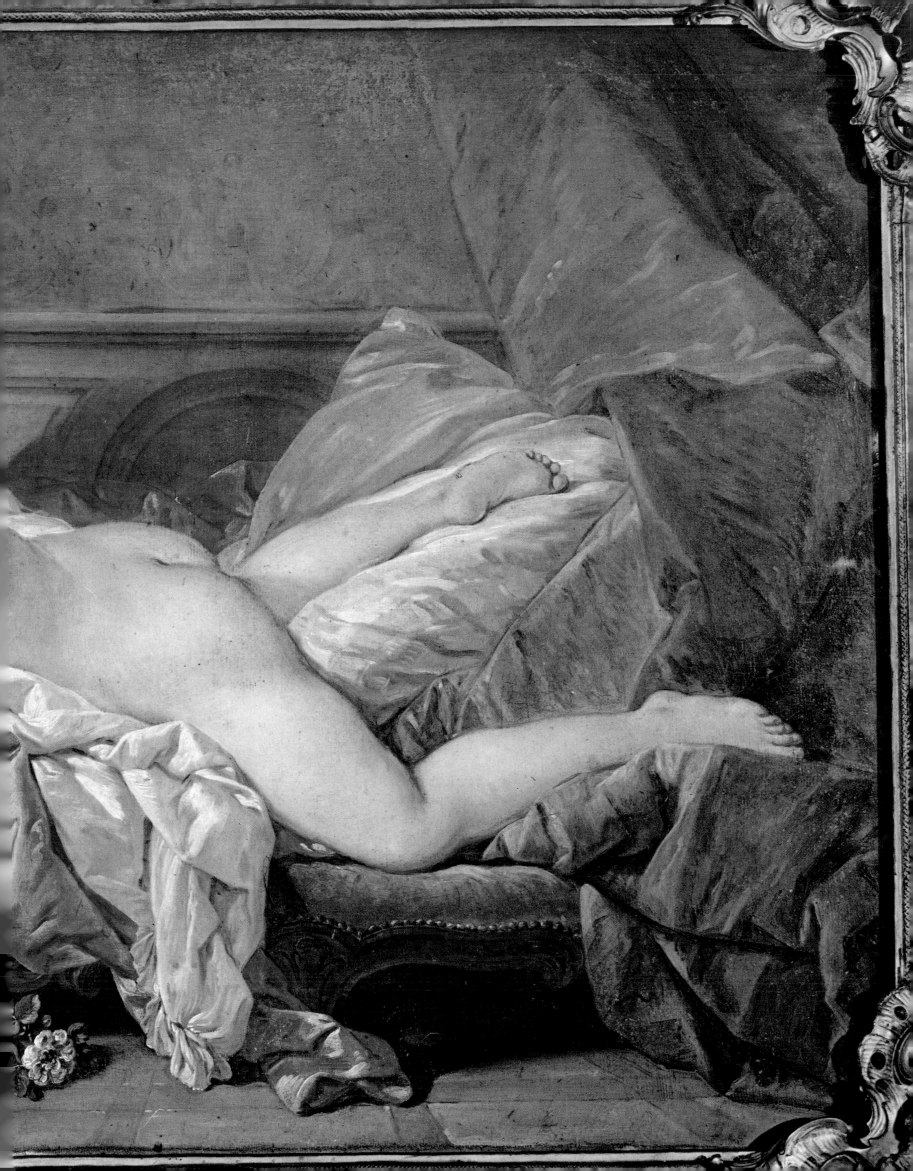

Fragonard: *Bathers*, 64×80cm, c.1765–70

The subject of 'Bathers', neither a depiction of a contemporary scene nor one from mythology, marks a new departure in art, and was to justify much nude painting in the nineteenth and twentieth centuries. This work, together with Rembrandt's *Bathsheba* formed part of the La Caze Collection, which in 1869 was presented to the Louvre; when publicly exhibited at this time, its remarkable freedom of technique must have acted as a strong stimulus to the art of the Impressionists, and it certainly was a direct precursor of Renoir's *Grandes Baigneuses* of 1887.

precise identification of the model, leave little to the imagination, scholarly or otherwise. The very epitome of the nude as 'pin-up', she serves as a perfect introduction to the new spirit of the Rococo. The total inability of a painting like the *Mademoiselle Murphy* to prompt deep reflections typifies much eighteenth-century art. Even in subject paintings meaning is so manifestly irrelevant that not even scholars have preserved to find one; eventually pictures of bathing Dianas or Bathshebas simply are entitled *Bathers*. However hard one might try to give classical respectability to the mythological world of an artist like Boucher, the Goncourts were quite right in characterizing his divinities as 'simply women who have undressed'. The over-abundance of nudes in subject painting had also the effect of making the human figure as decorative as the landscape in which it was set, and however erotic in intention, the mythological world of a Boucher can quite happily turn into the most harmless wallpaper. The voluptuously real carnality of the *Mademoiselle Murphy* painted in 1751 must be the result of direct copying from the model, but in the following year Reynolds, on a visit to Boucher's studio, was shocked to be told how the artist simply worked from memory. Fragonard's *Bathers* is another decorative work distilled from the imagination. But here at least the fiery technical brilliance gives delirious substance to the erotic dreams of an artist who once claimed that he would paint with his bottom. This work of Fragonard is the sublimated essence of sensuality, a state beyond both visible reality and subject-matter, and how appropriate that this man, who transformed art into no more than the most transient and pleasant of sensations, should have met his end while eating an ice cream.

When art expresses, without hypocrisy or embarrassment, a pure state of pleasure, the backlash of morality is inevitable. In the eighteenth century this role was assumed by Diderot; for him the art of Boucher was 'nothing but beauty spots, rouge, gee-gaws . . . the imagination of a man who spends his time with prostitutes of the lowest grade'.

David: *Intervention of the Sabine Women*, 386×
520cm, 1797

The founder of Rome, Romulus, one day seized the
women of the neighbouring tribe of the Sabines in an
attempt to boost the population of his own state;
many years later the Sabines attacked the Romans to
win them back, but these women, by now mothers,
interceded and begged for peace. David took the
unusual step of publicly exhibiting it in the National
Palace of the Sciences and the Arts. He wrote a
pamphlet to explain the painting's meaning and to
defend the nudity of its heroes, a feature which had
been much criticized at the time. David's defence was
that he wanted to 'represent the customs of antiquity
with such an exactitude that the Greeks and Romans,
had they seen the work, would not have found me a
stranger to their customs'. Stendhal later queried this
reasoning: 'And what do I care about classical bas-
reliefs? . . . The Greeks liked the naked body, but we,
for our part, never see it, indeed I should even say that
it disgusts us.' The absurdity of David's ideals was
brought out when a group of his followers, the
Primitifs, tried, in the late 1790s, to apply to everyday
life David's belief in returning to the simplicity of the
Greeks, and dressed up in antique dress, and bathed
naked in the Seine.

The moral stirrings of such men as Diderot were reinforced
by the French Revolution, and out of this new morality came
Louis David. His *Death of Marat* depicting Marat's murder in
his bath, is a semi-nude of almost religious fervour, an ex-
ample of nakedness giving classical status to a contem-
porary subject. The nudity is nonetheless idealized, for David
has taken no account of the psoriasis from which Marat
suffered. When the revolutionary fervour which engendered
such a work died down — and as classical values were being
undermined — the idealization of the body began to seem
anachronistic. David, who did more than any other artist to
dispel the prettified Rococo concept of the body, must also be
held responsible for encouraging the dreariest academic
nudes, often placed in the most incongruous settings. His
later *Rape of the Sabines* understandably met with consider-
able criticism for this very reason, not least from the ever
astute Stendhal: 'What sympathy can a Frenchman, who
has never held a sword in his life, feel for people fighting in
the nude? The most ordinary common sense tells us that the
legs of those soldiers would soon be covered in blood and
that it was absurd to go naked into battle at any time in
history.'

The dehumanization of the nude, the usual result of its
being transformed into an academic discipline, besets the

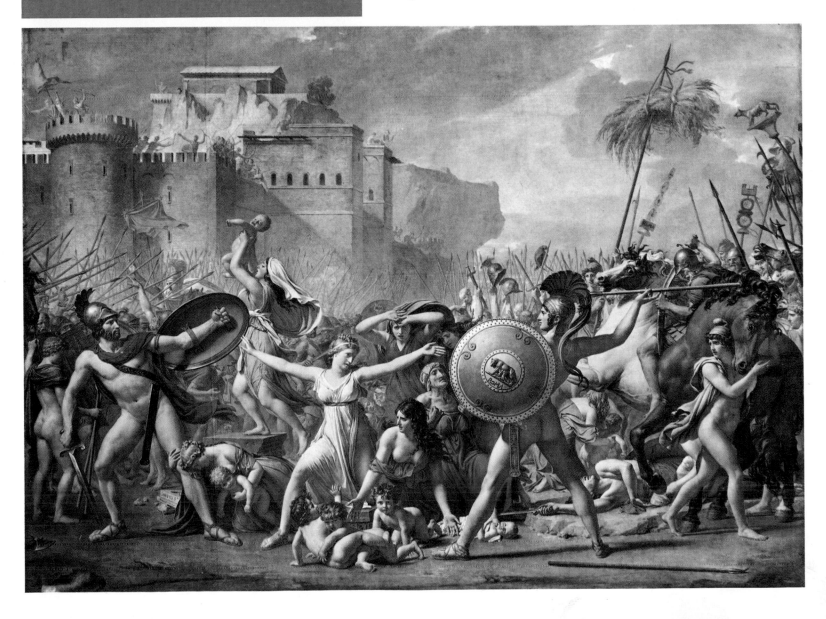

work of David's followers, but the impersonal quality of the works of Ingres is of a completely different kind. It is not the outcome of slavishly copying from the classically posed model, but of a repressed erotic imagination. Baudelaire was one of the first to recognize that behind Ingres, a famous figure of the establishment was a 'deeply sensuous nature'; absurd though many of his works are, they transcend academic conventions through a highly personal vision. When Ingres said, of the muscles of the human body, that 'they are

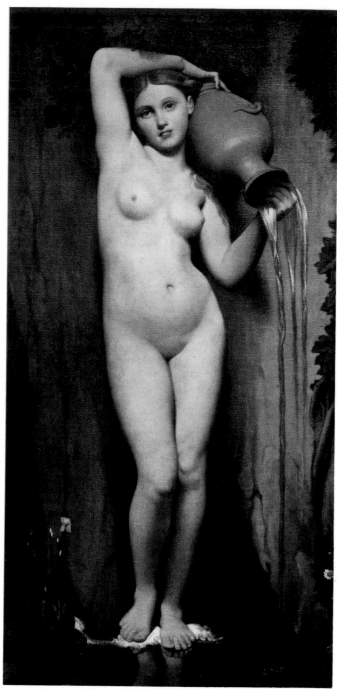

Below **Ingres:** *The Turkish Bath*, 108cm in diameter, 1862

In 1819 Ingres copied down in his notebook a passage from a letter (written in 1717 and published in French in 1805) by Lady Mary Wortley Montagu, the wife of the English ambassador to Constantinople. In this Montagu described the women's bath in that city, in which 200 women, many of great beauty and white-ness of skin, paraded entirely in the nude, bathing, drinking coffee and gossiping. This image of oriental indolence and exotic sensuality remained with Ingres until the very end of his life, when he finally tried to convey the scene in paint. Commissioned in the late 1850s by Comte Démido, the work was bought in 1859 by his brother-in-law, Joseph Bonaparte, Prince Napoleon; the latter's wife was, however, so shocked by the abundance of nudes that the Prince was obliged to exchange it for another work by Ingres. The painting was then reduced to circular format and received in 1862 the proud inscription that Ingres completed it aged eighty-three. Finally, in 1865, it was sold by the artist to the notorious Khalil Bey, who was later to commission Courbet's *Sleepers*.

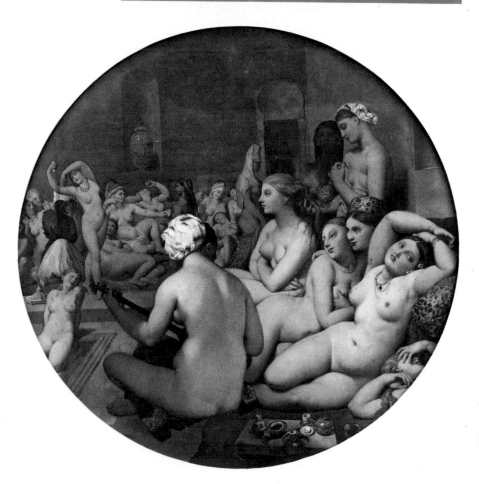

Above **Ingres:** *The Source*, 164 × 82cm, 1855

Originally a realistic life-study, the work was begun in Florence in the 1820s and remained unfinished in the artist's studio for over thirty years. Ingres finally brought it to completion in 1855, adding, with the help of assistants, the urn and the background. The work was one of the most popular in the nineteenth century, and, when he sold it to Comte Duchâtel for the absurdly high price of 25,000 francs, the artist wrote that this was not much considering 'all the fuss made of it in Paris'. For the Goncourts, how-ever, the work epitomized the 'insipid ideal of academic beauty; it is not real. In contrast the nudes of a Boucher are great, because the artist depicted the women of his own time'.

my friends, but I do not know their names', he was both defending the importance of studying from nature and emphasizing his own unpedantic and spontaneous approach. Although brilliantly successful as an artist, his nudes, from the very start, shocked and surprised the more conventional canons of taste. His first major exhibited nude, the *Valpinę Bather*, was severely criticized for its lack of modelling, and the later *Grande Odalisque* was condemned for this same quality and for its oddly distended anatomy. The containment of smooth frigid substance within an elegant and exaggeratedly curvaceous linear pattern makes Ingres closer in spirit to Bronzino than to his contemporaries. The public of his time thus found it much easier to appreciate what is now regarded as his blandest and most conventional nude, *The Source*, a work which indeed became the most reproduced and highly priced nude of the century. The academically correct and static poise of the figure seems to be by a very different artist to the one whose distortions of the body culminated in the great masterpiece of his old age, *The Turkish Bath*, in which the curves of the human form gyrate like the navel of a belly dancer.

Traditionally, in contrast to Ingres, Delacroix has been regarded as the more emotional and imaginative artist. The two of them, in fact, shared a similar inability to live up to their respective images, for behind the more openly passionate art of Delacroix, is a man of much more rigorous intellectual discipline, whose vast *corpus* of writings puts the slender, pocket-sized collection of Ingres' *Thoughts* to shame. Both artists went beyond the straightforward depiction of the human body, although in entirely different ways, the one through line, the other through colour. The very early study of *Mademoiselle Rose* in the Louvre is an exceptional work of Delacroix, belonging to an early period of his art when he was still under the influence of a classical apprenticeship, and only differing from countless other academic studies by its very vivid and life-like rendering of flesh and blood. Later Delacroix began to despise strict adherence to the model, and, indeed, surprised Monet by the number of times he sent the model away before painting. If one looks at some of the coarsely physical models which Delacroix photographed, one can understand how, in a letter of 1811, the artist could write that 'it is from the cruel reality of objects that I am trying to escape when I take refuge in artistic

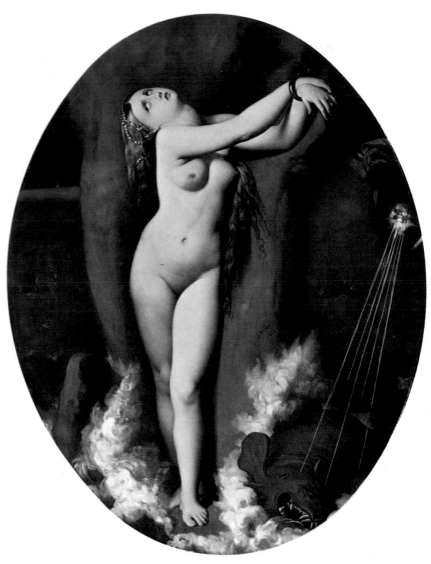

Ingres: *Angelica*, 97 × 75cm, 1859

recreation.' Delacroix's intensely passionate nature, unable to find specific fulfilment, is illustrated by an anecdote related by Merimée, in which a group of friends encouraged six young girls to do gymnastics in the nude: 'Delacroix was besides himself – puffing and blowing as if he wanted to take on the whole six of them at once.' In his most erotically

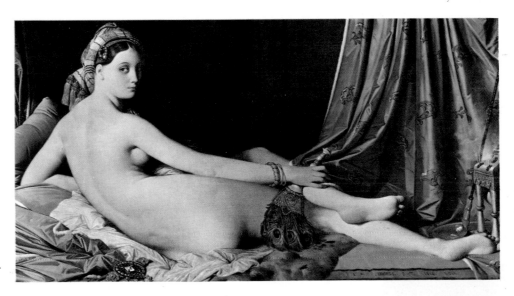

Ingres: *La Grande Odalisque*.
91 × 162cm, 1814

Delacroix: *The Death of Sardanapalus*, 395×495cm, 1827

When exhibited in the French *Salon* of 1827 this painting met with very hostile criticism, so that Delacroix referred to the work as his 'retreat from Moscow'. Delacroix's painting represented all that was most abhorred in Romantic art — an irrational composition, a ridiculously dramatic subject and an abandonment of line in favour of an excessive use of colour. The theme was inspired by Byron's play, *Sardanapalus* (1821) which ended in the dissipated Assyrian monarch committing suicide on an enormous pyre built under his throne. The massacre of the concubines was Delacroix's own addition, an opportunity to depict beautiful nudes in seductive postures, figures described by the great-nineteenth-century critic, Theophile Gautier, as 'flowers of the harem . . . (who), surprised in the postures of death, which are precisely those of sensual delight, emit a violent odor of flesh'.

powerful works, like *The Death of Sardanapulus*, it is as if the paint itself is struggling to substantiate this generalized emotion of intangible sensuality, and in the frustration which this process engenders, violence inevitably erupts. In the case of *The Sardanapulus*, based most probably on a poem by Byron, the killing off of the concubines is a totally gratuitous distortion of the literary text, a mixture of eroticism and violence, somehow incongruous with the highly rational and conventional character of the artist.

Delacroix was horrified by the diametrically opposed creative technique of Courbet, and described with scorn how the latter painted the bottom of a woman bathing from a detailed study next to his easel: 'Nothing is more cold; it is

OPPOSITE **Gericault:** *Raft of the Medusa* (detail), 1819

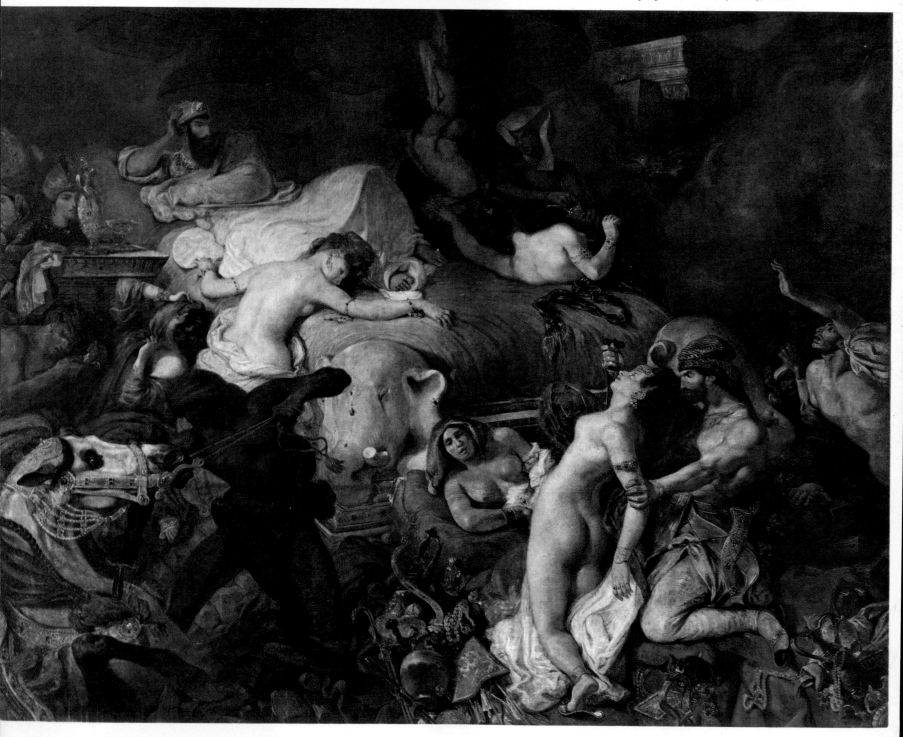

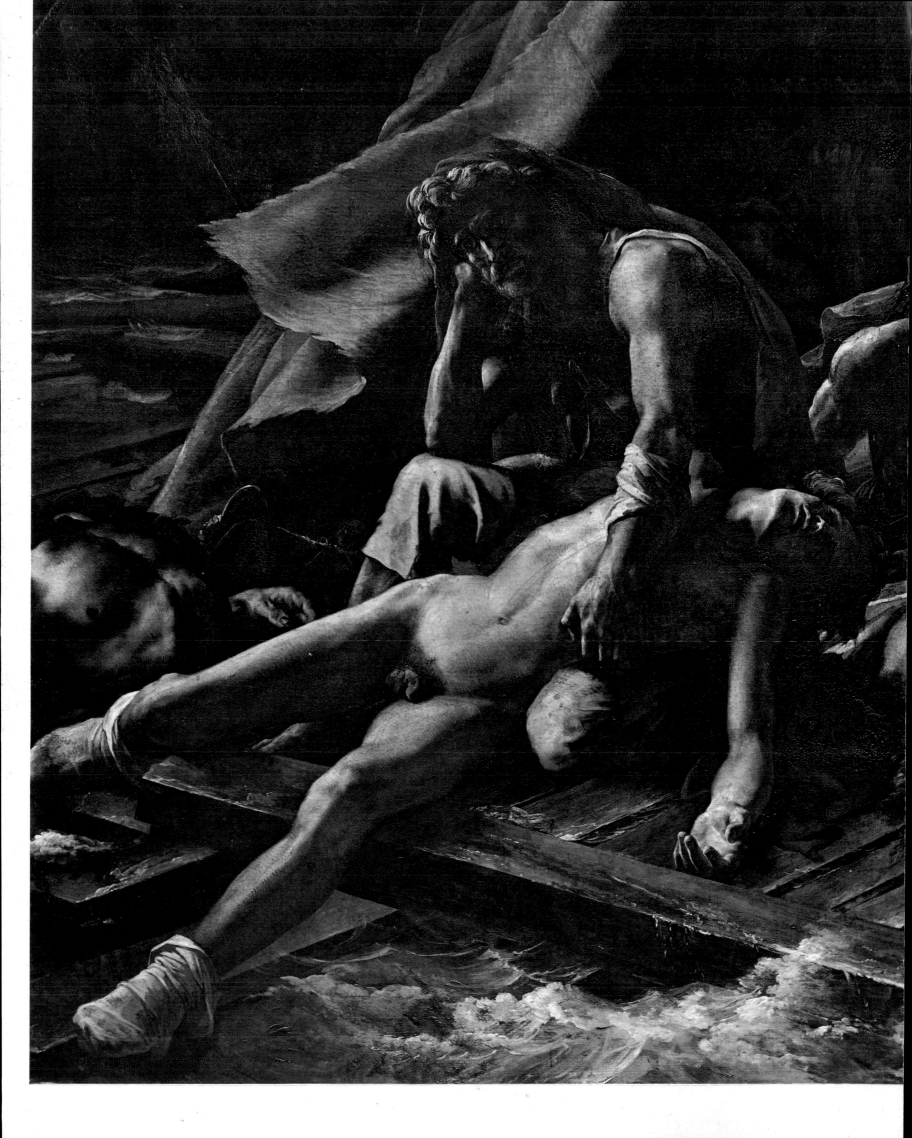

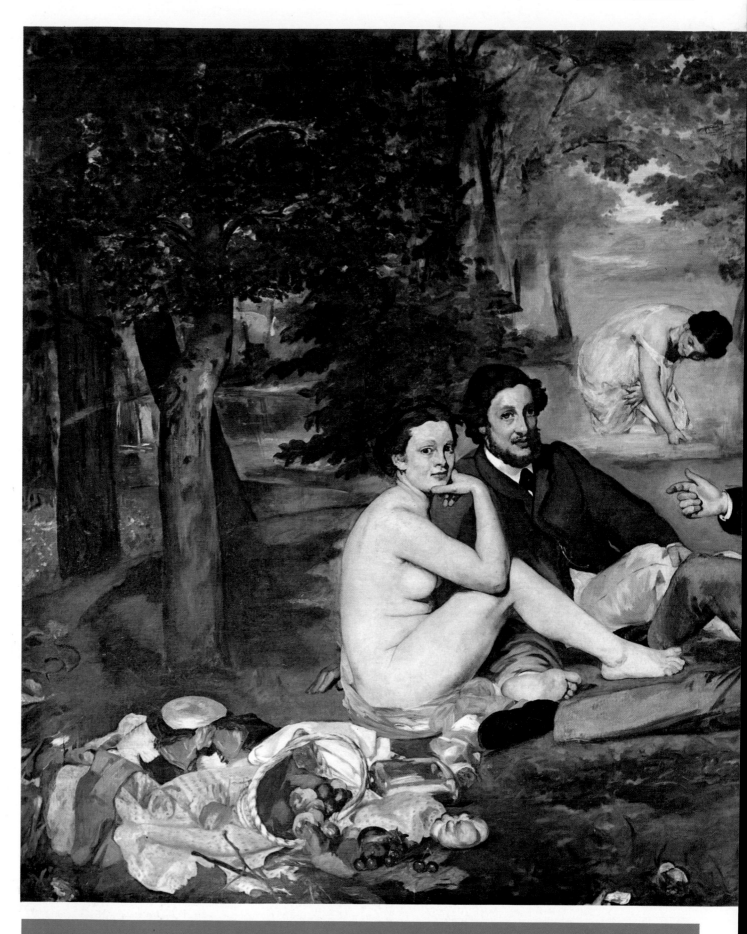

Manet: *Déjeuner sur l'Herbe*, 208× 264·5cm, 1863

The painting, originally entitled *Le Bain* ('The Swim') was, according to a friend of Manet, Antonin Proust, inspired by a Sunday excursion to the Seine at Argenteuil: 'Some women were bathing. Manet had his eye fixed on the flesh of those coming out of the water. "It appears," he said, "that I must do a nude. Very well, I'll do one. When we were at Couture's I copied Giorgione's *Concert Champêtre*. It is black that picture; the dark priming has come through. I want to do that over again in terms of transparent light and with people like these."' The models for the painting were the artist's brother Gustave, his later brother-in-law, Ferdinand Leenhoff, and Victorine Meurent, who also posed for the *Olympia*. The composition, as was recognized as early as 1863, was based exactly on an engraving after Raphael's lost *Judgement of Paris*.

however, without equal, something most amply proved by his later nudes. To the critics who had previously championed his revolutionary and unsparing realism, these more voluptuous creations were seen in terms of the artist pandering to popular taste. By using more obviously pretty models, and placing them in unreal and tasteful settings, Courbet had certainly found a formula to win popularity without causing offence. The most erotic were nonetheless not for public consumption. The so-called *Sleepers* was commissioned by the former Turkish ambassador in St. Petersburg, Khalil Bey, who in 1865 had bought *The Turkish Bath*. Little more need be said about his taste in art, except that the other Courbet ordered by him, a detailed study of a vagina, is still never reproduced. The idea for the *Sleepers* came about when Khalil Bey, excited by a description of *Venus and Psyche* begged him for a copy, to which the artist replied that instead he would do for him 'a picture called *Afterwards*'. The resulting painting is only paralleled, in its sensuous interlocking of forms, by *The Turkish Bath*, but leaves even less to the imagination, substituting the suggestion of line with the tangible indisputability of flesh.

For a century which produced such a variety of erotically charged nudes as the nineteenth century – not least the work of Victorian classicists like Lord Leighton – distinctions between what was seen as offensive and what was not, make a fascinating study in psychology. The clue to respectability was provided by Renoir in a description of his painting, *Diana*, of 1867: 'I intended to nothing more than a study of a nude. But the picture was considered pretty improper, so I put a bow in her hand and a deer at her feet. I added the skin of an animal to make her nakedness less blatant – and the picture became a *Diana*.' The hypocrisy of Second Empire Society in France, where paintings like Courbet's *Woman with a Parrot* or Cabanel's *Birth of Venus* could achieve uncontroversial popularity because they were reminders of the great Venuses of the past, is highlighted by the famous scandal caused by Manet's *Déjeuner sur l'Herbe* and *Olympia*. Ever since these were painted, their highly respectable

like inlaid woodwork.' This description is hardly appropriate to an artist who painted some of the most substantially fleshy nudes of the century, but Delacroix was also perturbed by the grossly materialistic quality of an artist who placed the naked woman on a par with his other pleasures of eating, drinking and hunting. He attacked Courbet's *Bathers* for 'both the vulgarity of the forms', and, more importantly, for 'the vulgarity and pointlessness of the idea'. The picture is indeed an odd mixture of realism and meaningless pseudo-classical posturing. As a painter of flesh alone, Courbet was,

Pages 64-5. **Manet:** *Olympia*, 130·5×190cm, 1865

The painting clearly reflects Titian's *Venus of Urbino*, a work which Manet, like many students of the time, had copied, on a visit to Florence in 1836. After the notoriety of the *Déjeuner sur l'Herbe*, the choice of *Olympia* for the *Salon* of 1865 might have been an inspired attempt to boost gallery attendance. Manet himself must also have been out to provoke, for not only did he make fun of a famous Renaissance painting but also, by placing what was described at the time as a 'female gorilla made of india-rubber, outlined in black' in an absurdly exotic setting, parodied the sort of dubious painting which was acceptable at the time; the joke was crystallized in some pseudo-Baudelairean lines of poetry attached to the title, in which Olympia, symbolizing both dawn and spring, was described as an 'august young girl'. Physical attacks to the canvas resulted in its being placed out of reach above a door, so that, in the words of a contemporary, 'You scarcely knew whether you were looking at a parcel of nude flesh or a bundle of laundry.'

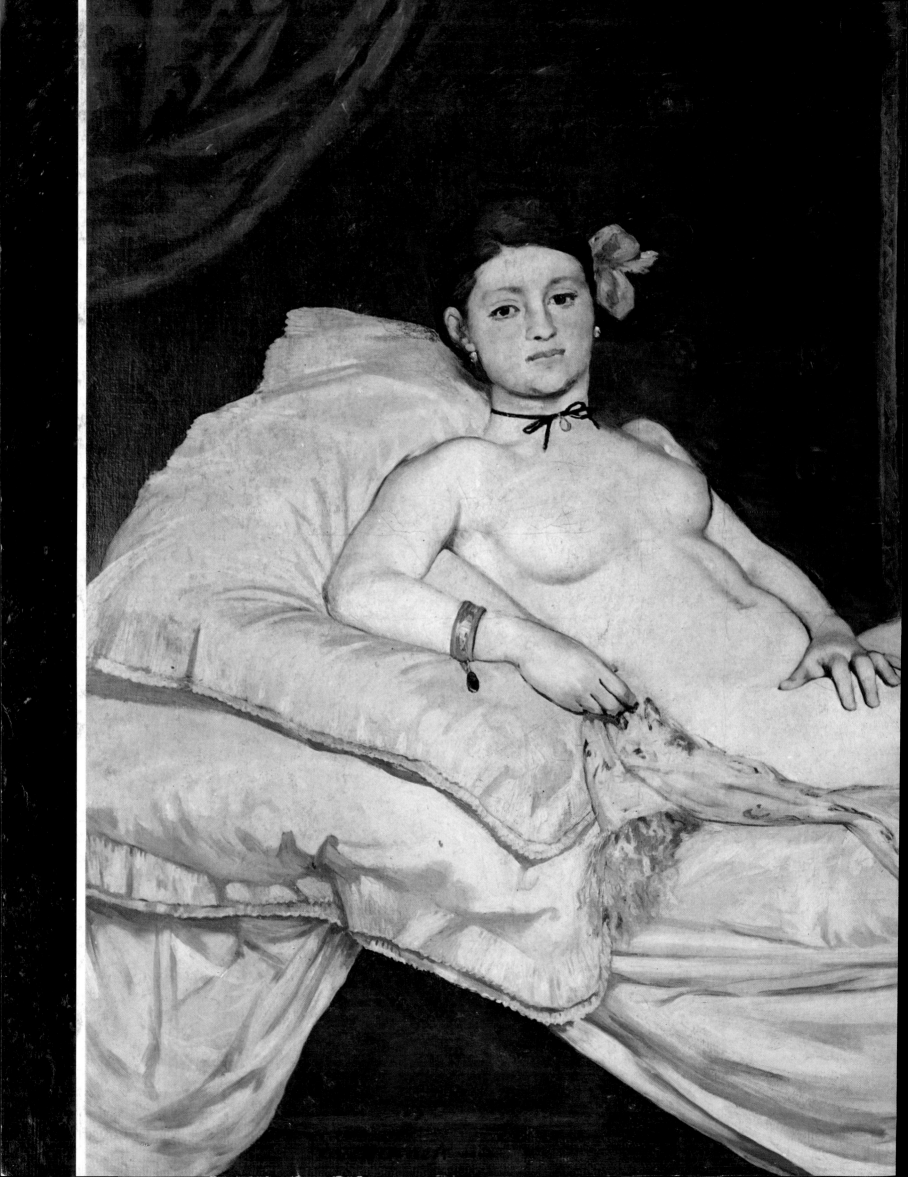

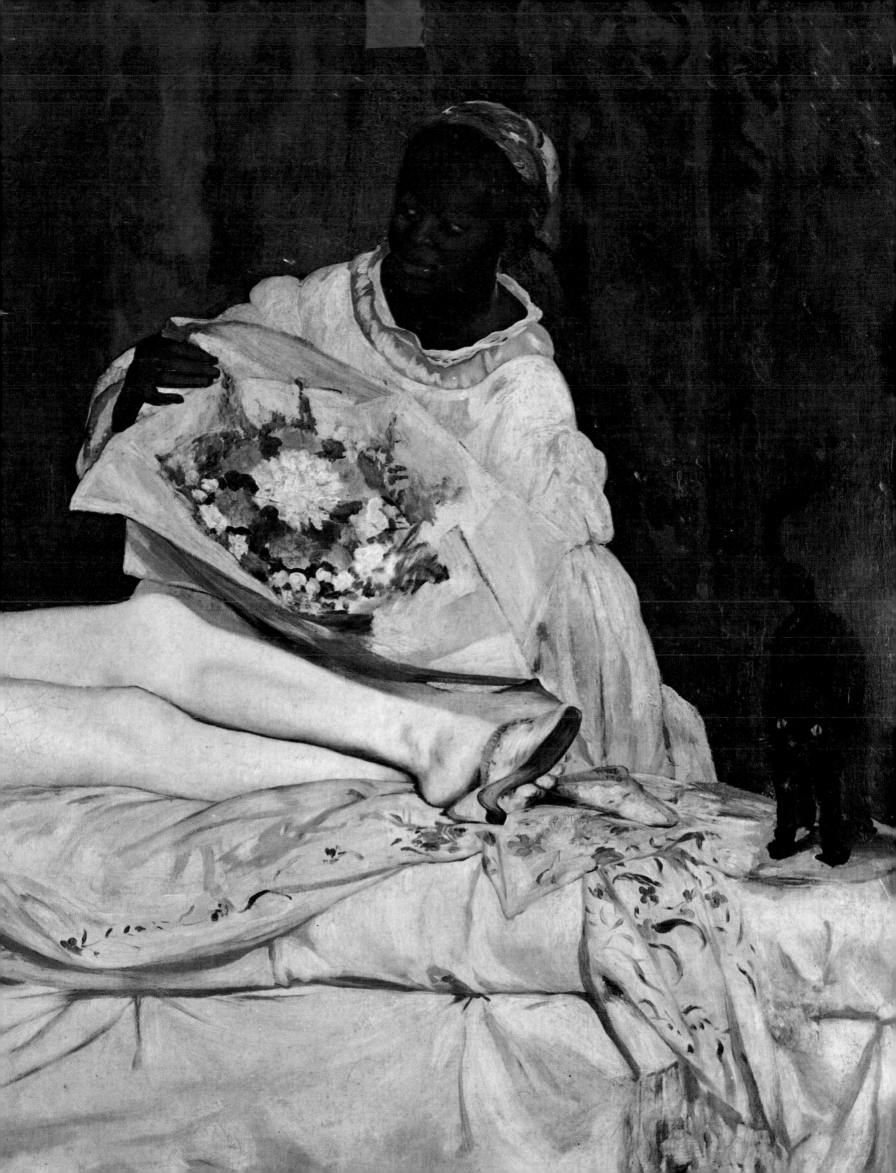

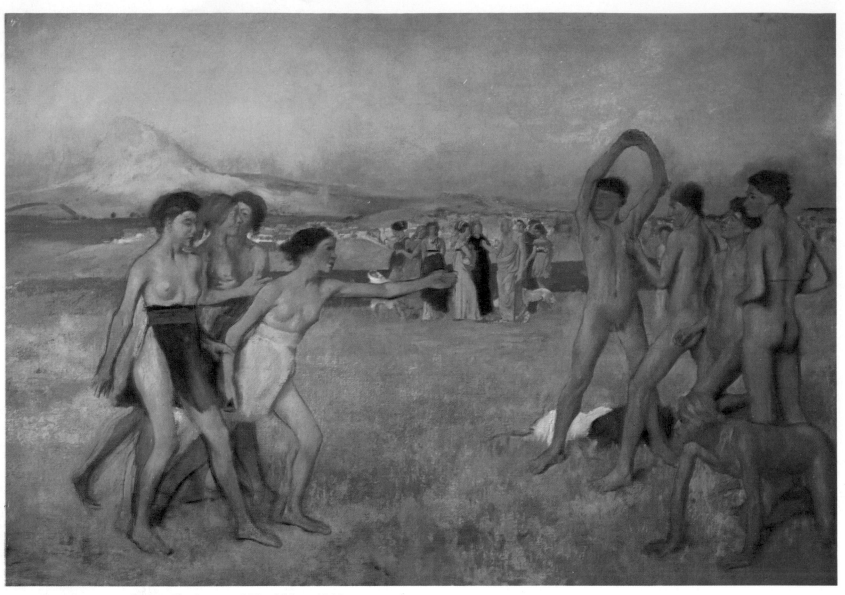

Degas: *The Spartans*, 109 × 154cm, 1860

sources of inspiration (a combination of the *Concert Cham-pêtre* and an engraving after Raphael for the first, and the *Venus of Urbino* for the second) have been well known, but the assumption has always been that these were used purely as an attempt to pacify the public. Surely Manet's two paintings must be interpreted instead as brilliant parodies, purposely setting out to shock a public accustomed to reverential worship of the Renaissance, and perceptively emphasizing the true nature of the works in question. This is achieved in the *Déjeuner* by a juxtaposition of the realistic and the pseudo-pastoral, and, in the *Olympia*, by the inclusion of a Second Empire courtesan – the classically inspired gesture of modesty of Titian's Venus transformed into one which actually makes one aware of the existence of genitalia – in a ludicrously exotic setting. Interpreted as jokes, the paintings were certainly successful, for few works of art could have had such enormous crowds of people coming to laugh at them. As always, the angry voices of morality had only the effect of increasing the works' notoriety, encouraging visits from the most conventional Parisians who would never have set foot into an art gallery. More ironically, the paintings, now regarded as key works in the history of Impressionism, have earned the same humourless respect as the Renaissance works which had engendered them.

Of the artists associated with Impressionism, the most genuinely interested in the nude were Degas and Renoir. The former was the more innovatory of the two, taking the most extreme stylistic liberties, even while remaining conscious of the art of the past. At the root of his art was an overwhelming respect for Ingres' linear style, and few artists have developed to such an extent the possibilities of emotional power contained within the rigid discipline of line. In two early works, the National Gallery, London *Spartans*, and the Louvre *Scenes of War in the Middle Ages*, he had used emotionally active nudes in a dynamic recreation of the past; but in later life, in his search for the greatest economy of expression, he concentrated his nudes into the completely contemporary setting of the bath-tub and its surroundings. The photographic abruptness of his compositions and the originality in the posing of his figures, has something of the spontaneity of life, and he was one of the first artists to explain his subject's nakedness in terms of the actions in which they were involved, washing, wiping their bodies, drying their hair after the bath. In his constant attempts to escape from the stereotyped poses with which the nude was associated, no artist could have been harder on his models, who were forced to assume the most contracted positions. When he took up sculpture in old age, at a time when his eyesight was almost failing him, there are gruesome stories of his clumsy handling of giant callipers with which he measured, and lacerated, his models. His eyesight was by then so poor that he had virtually given up painting, and concentrated instead on his pastels, which had become gradually freer and more vigorous in technique, and contained only the essential details; in the

ABOVE **Degas:** *The Tub*, 60 × 83cm, 1886

RIGHT **Degas:** *Woman Combing her Hair*, 82 × 57cm

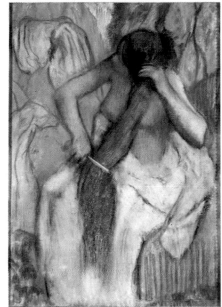

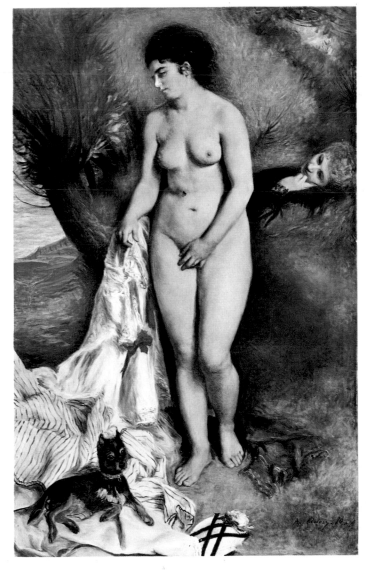

RIGHT **Degas:** *Woman at her Toilet*, 75 × 72·5cm, c.1903

way that Fragonard wanted to paint with his bottom, Renoir more practically claimed to use his penis. One feels in both their works a vibrant sensuality extending to every part of the canvas, but unlike Fragonard, or, for that matter, Rubens, whom Renoir also admired, Renoir's ever greater exaggerations of the female body, both formally and in terms of colour, are not just expressive of health and vitality, but of a diminishing artistic control.

Whether expressed by beauty of line, as in Degas, or by the more colourfully sensual works of Renoir, both artists had a belief in the human body as something to be admired; this belief, a legacy, however distant, of the classical attitude

end, little was left but the heaviest outlines struggling to capture amidst growing patches of pure colour the essence of the human figure, a moment when he could exclaim, as he did on one occasion 'Voici l'animal!' ('There's the beast!').

Degas is unfairly characterized as a misogynist, though his passionately active nudes are at heart kinder to women than the sentimental and idealized conceptions of the aggravatingly heterosexual Renoir. Renoir, who has become one of the most popular nude painters of all time, maintained an essentially conventional approach to the subject, placing his figures in blandly timeless settings, and he was acutely aware of classical prototypes: 'The most simple subjects are eternal, the nude woman whether she emerges from the waves of the sea, or from their own bed, is Venus or Nios; and one's imagination cannot conceive anything better.' In the same

Renoir: *The Bather and the Griffin*, 184 × 115cm, 1870

Exhibited in the French *Salon* of 1870, the painting was the first to achieve great popularity for the artist, who indeed had to wait a further twenty years for a comparable public success. The pose of the figure is an undisguised copy of the Cnidian Venus of antiquity, and the relatively dark colouring and realistic handling of flesh owe much to Courbet.

Bonnard: *The Nude Woman*, 64 × 79cm

towards the nude, has prevailed into the present century. This tradition, at its most intentionally sensual, was continued in the art of Bonnard or Modigliani; Bonnard taking over superficially from Degas in his restriction of the nude to

Bonnard: *Nude against the Light*, 125 × 109cm, 1919–20

a contemporary interior, Modigliani in his description of the body through simplicity of line. The self-conscious posing of Bonnard's nudes – inactive even in their baths – and the emphatic prettiness of Modigliani's – which, even at their

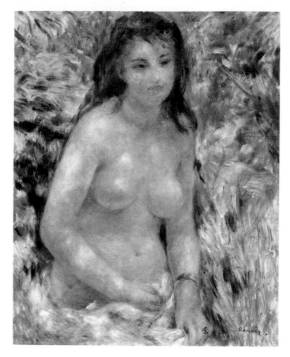

Renoir: *The Torso of a Young Woman in the Sunlight*, 81 × 64cm, 1870

most stiffly recumbent and stylized, still retain an appealing delicacy of modelling and an emphasis on specific, sensually arousing details – have little to do with either dynamic purpose or the purity of form, beloved of art critics. The nudes of Matisse, on the other hand, more deceptively simple than those of Modigliani, are the products of a complex intelligence. His *Dance*, shows greater linear containment of the

Pages 72–3. **Matisse:** *The Dance*, 261 × 390cm, 1909

This is a large-scale design for one of two decorations, *Dance* and *Music*, commissioned from Matisse in 1900 for the sumptuous Rococo residence of Sergei Shchukin, a Russian importer living in Moscow. Shchukin, who owned one of the largest collections of contemporary French paintings of the time was deeply impressed by Matisse's design: 'I find your panel, *The Dance*, of such nobility that I am resolved to brave our bourgeois opinion and hang on my staircase a subject with nudes.' When Matisse actually completed the two works, which created a great stir in the French *Salon* of 1910, Shchukin lost heart and told Matisse that as he had subsequently adopted two young girls, he felt that the paintings would be unsuitable for his respectable house and feared a scandal. Eventually he capitulated, and both paintings were hung, though not before a fig leaf retouching of the *Music*. Although it is very difficult to understand how such a work as *The Dance* could possibly have morally offended (it is even difficult to distinguish between the sexes), its shocking visual impact, both in terms of its powerfully ecstatic movement and brightness of colour, is another matter, and Matisse himself was disturbed by this, being aware for some time of the canvas vibrating and quivering in the evening; on one occasion he even jumped back in surprise on catching a sudden glimpse of his own creation.

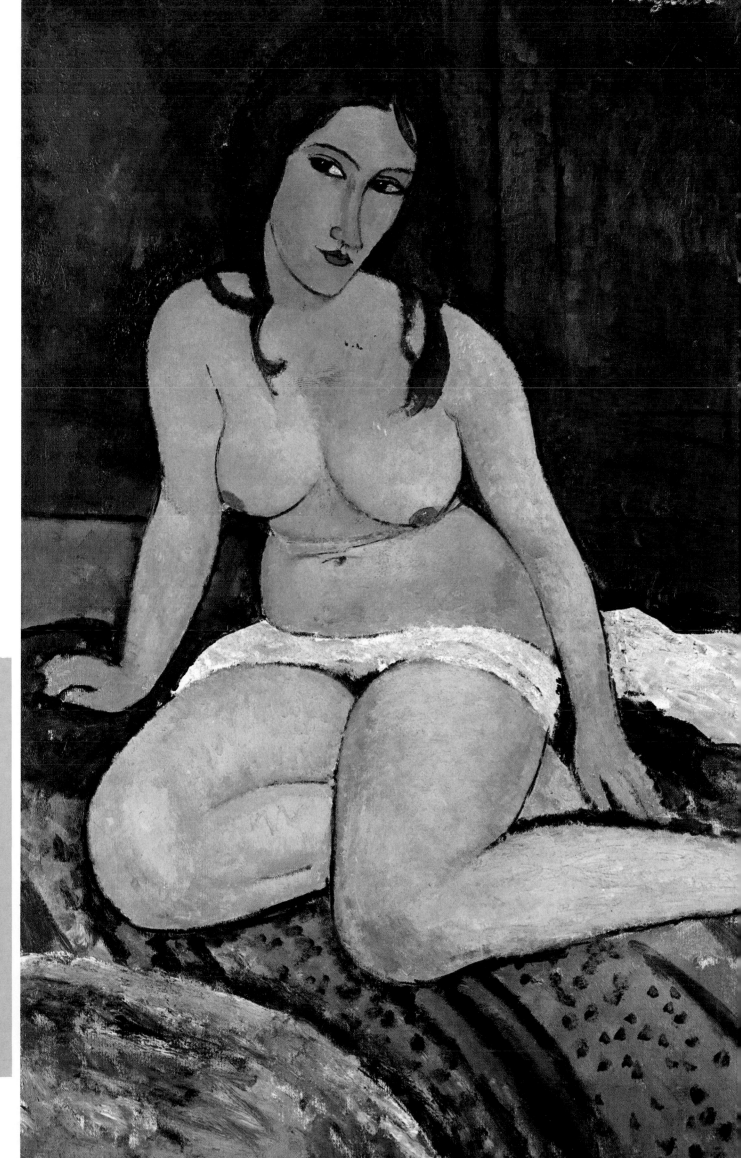

Modigliani: *Seated Nude*, 114×74cm, 1917

Virtually all Modigliani nudes date from 1917, just two years before his untimely death from tuberculosis at the age of thirty-two. Many· were exhibited in his first one-man show in December 1917, which was closed by police claiming that the nudes in the window of the gallery had caused a public scandal.

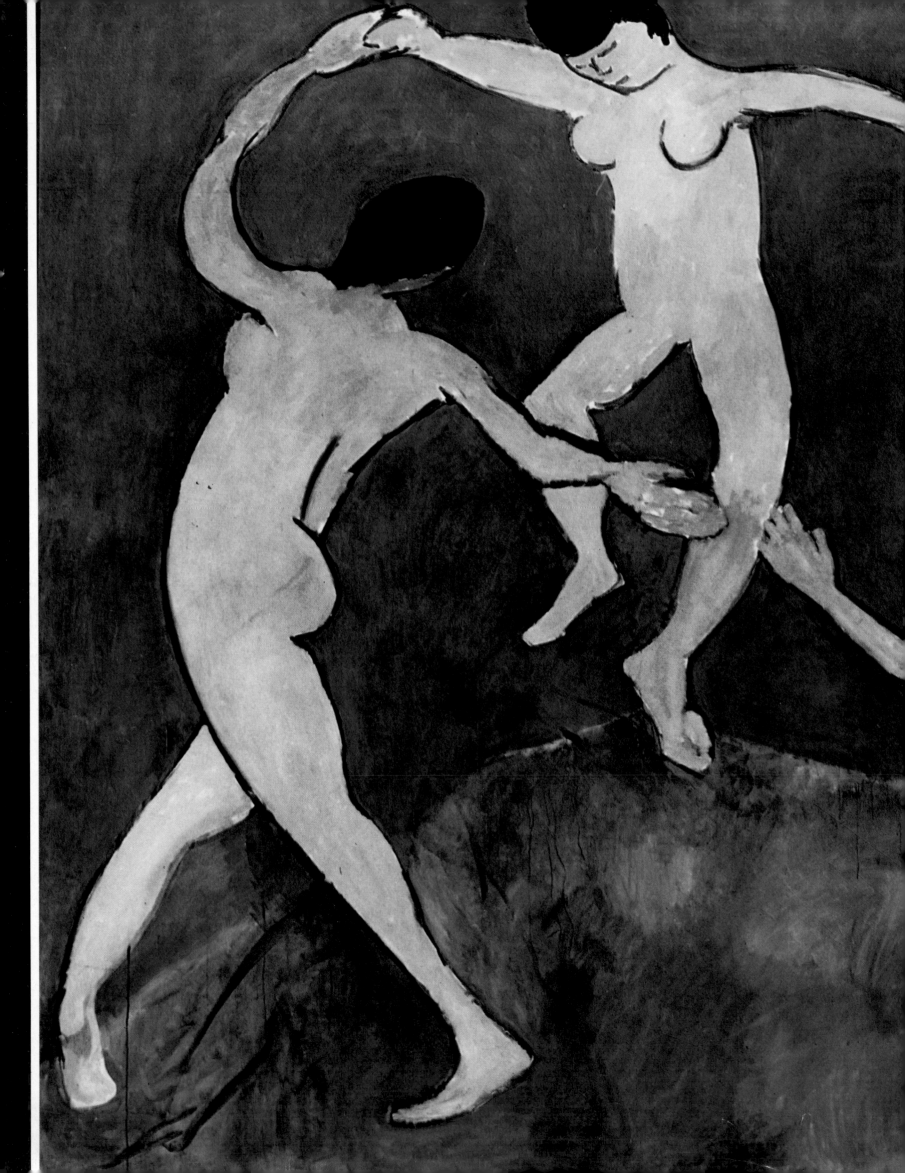

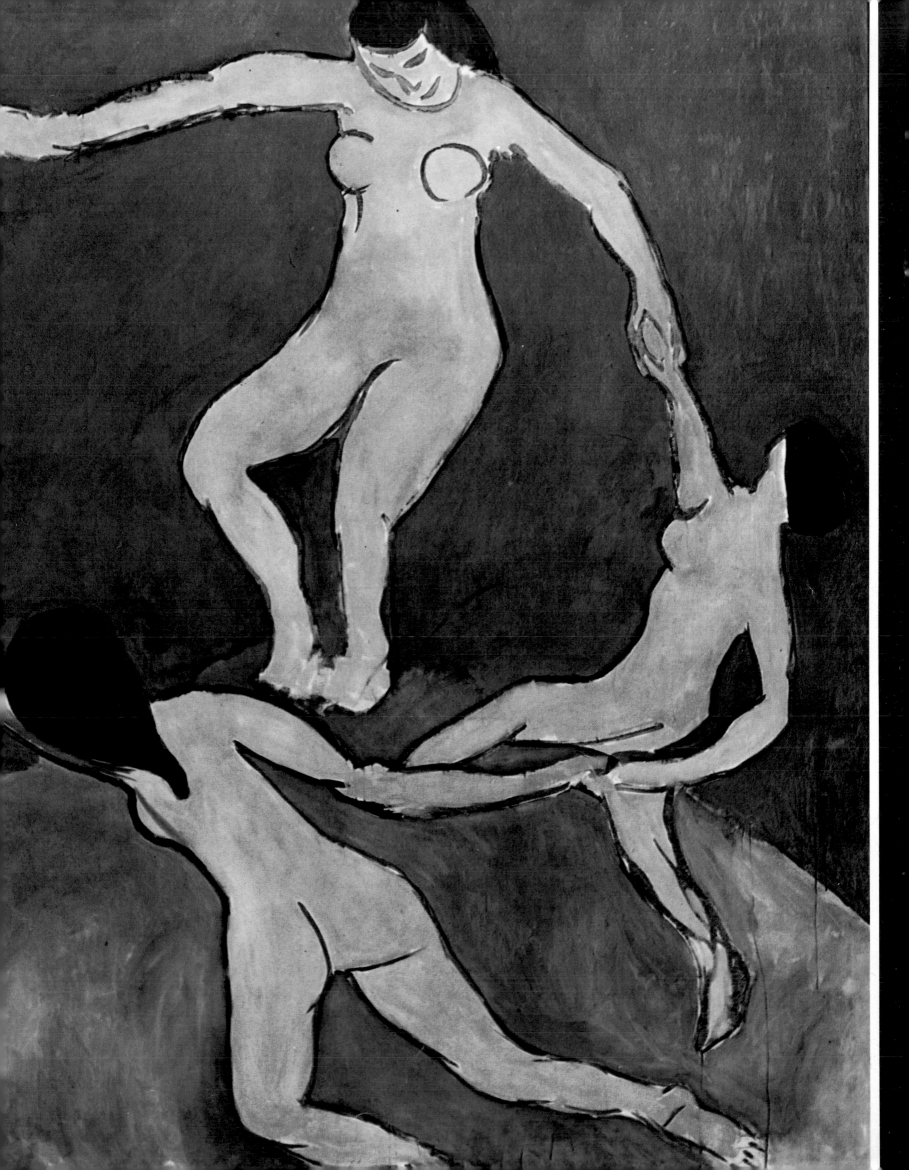

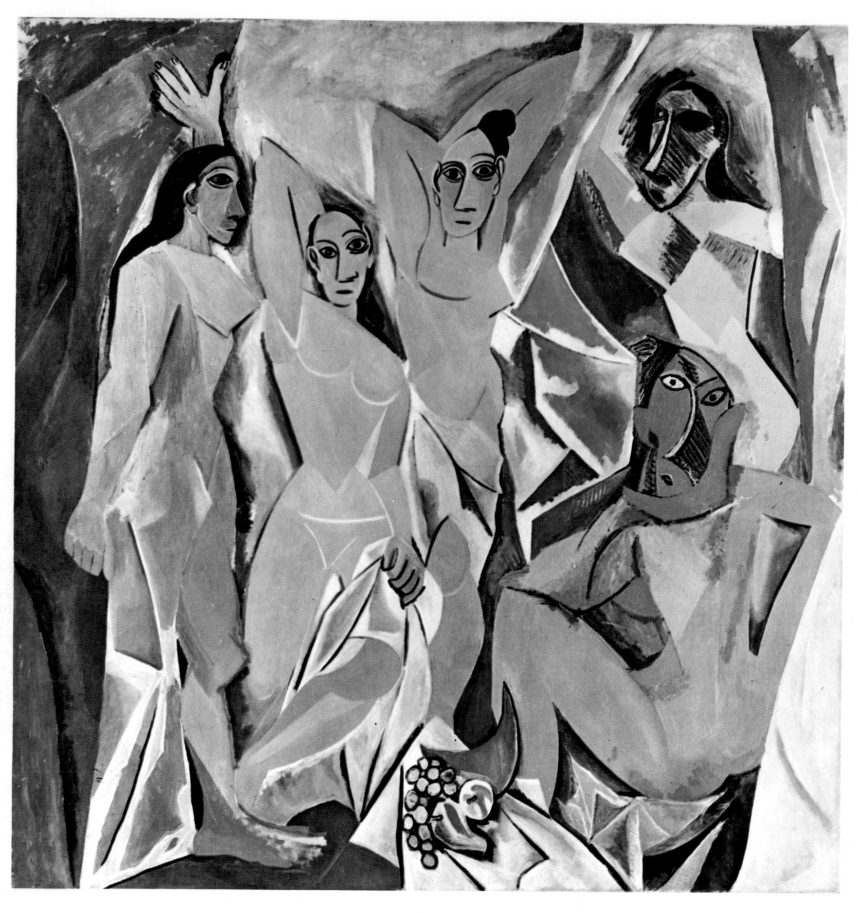

figure, and one which will lead to the ultimate simplicity of his late nudes. With this work, line has ceased to be merely descriptive, acquiring a life of its own, in which the rendering of sensual forms has become subordinate to an overall pattern expressive of human vitality. The Chicago *Bathers by a River*, although of the same date, is in a very different style. The new spirit of austerity, accentuated by the subdued colouring, goes further in the direction of abstraction. Neither human nor sensuous, these nudes nonetheless still assert the importance of the human body as a norm of beauty,

however unconventional, an attitude remaining with Matisse throughout his life.

The most potent influence on Matisse's *Bathers* seems to be the paintings of the same subject by Cézanne, all dating from the artist's late years, and works which marked a new departure in the history of nude painting. During the artist's early apprenticeship in Paris, he had shown an exaggerated love of the violent and erotic, and had amused both fellow teachers and students alike by his vigorous but coarse studies after the model. This highly passionate art marked the out-

Left **Picasso:** *Demoiselles d'Avignon*, 240 × 230cm, 1907

This work has great art-historical respectability. It was painted, after many months of sketches and preparatory studies, in, reputedly, a few days. Interestingly, one of the early studies showed a skull, an appropriate moralizing touch for a work in which the naked body has become the embodiment of fear. Along with the influence of Cézanne's *The Bathers*, Picasso claimed inspiration from pre-Roman Iberian sculptures in the Louvre; while painting the work, the artist also paid a visit to the Trocadero Museum, and was so struck by the primitive African carvings there that he later completely changed the right-hand side of the canvas. When exhibited in his studio in 1907, it met with almost universal disapproval, even from his closest friends and those who had originally championed his work. Matisse, for instance, was incensed, thinking that Picasso was making fun of the whole modern movement, and Shchukin, who had commissioned *The Dance* considered it to be an enormous 'loss to French art'. The title of the painting, given at a later stage, was partly inspired by a brothel street in Barcelona (Carrer d'Avinyo) and partly by a humorous suggestion that the Avignon grandmother of the poet, Max Jacob, had posed for one of the figures. After the failure of the work, Picasso wrapped up the canvas, and waited until 1937 before finally showing it to the public.

ward release of the repression caused by provincial puritanism, which he shared with his schoolfriend Zola; moreover, both their lives bore out a sense of physical unease with the opposite sex. Back in Aix-en-Provence, Cézanne made no further use of actual models, basing his nudes on a combination of photographs and memories. The *Bathers* places, within the most classically austere triangular composition, a series of clumsy, heavy and deformed figures; this is a state of nakedness which could be interpreted either as a puritanical dehumanization of the body in favour of a stiff geometrical conception of form, or the expression of a near primitive ethos.

Degas' exclamation of 'Voici l'animal!' was matched by a compensatory belief in dignifying the body through the beautiful concision of line. But much art of this century, taking over from the formally primitive quality of Cézanne's nudes, has indeed reduced the human being to little more than an animal. The first significant manifestation of this new attitude was Picasso's *Demoiselles d'Avignon*, a work

Matisse: *Bathers by a River*, 262 × 391·5cm, 1916–17

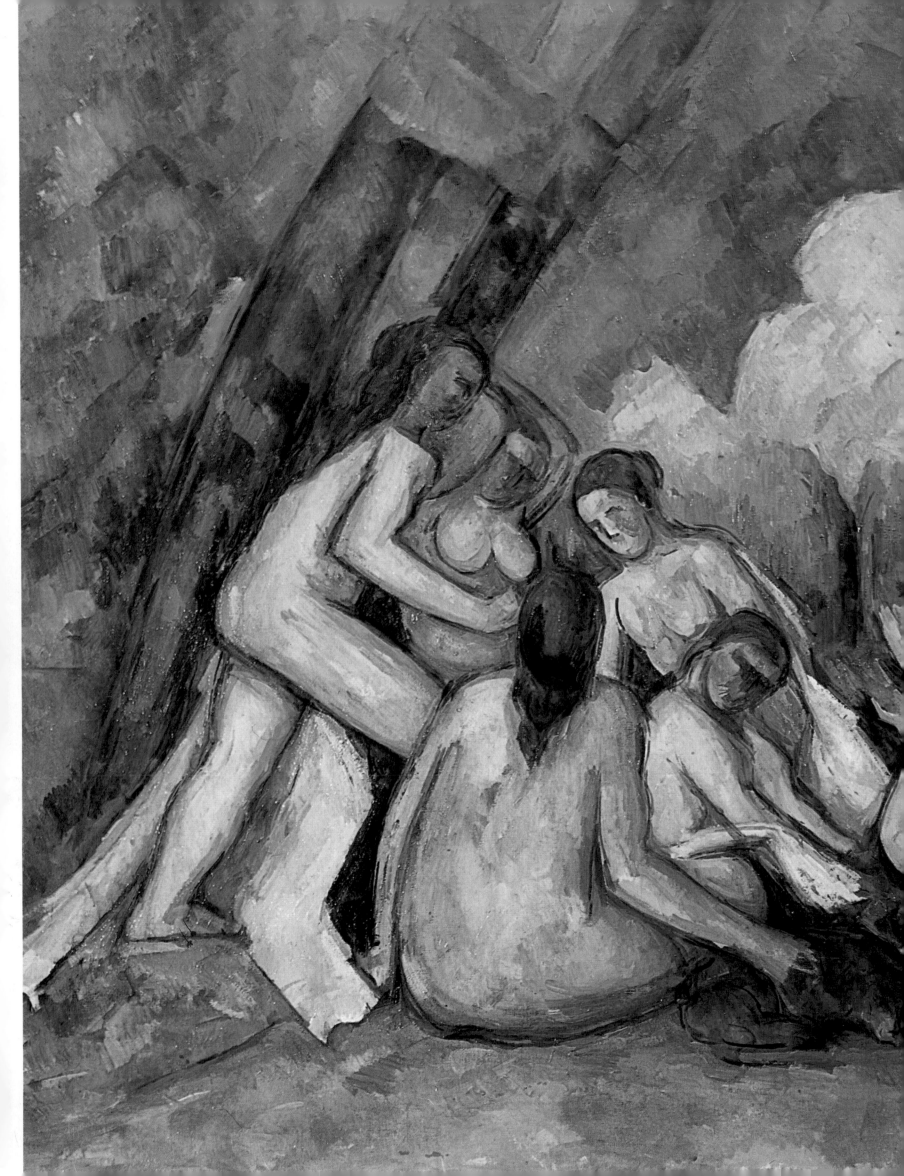

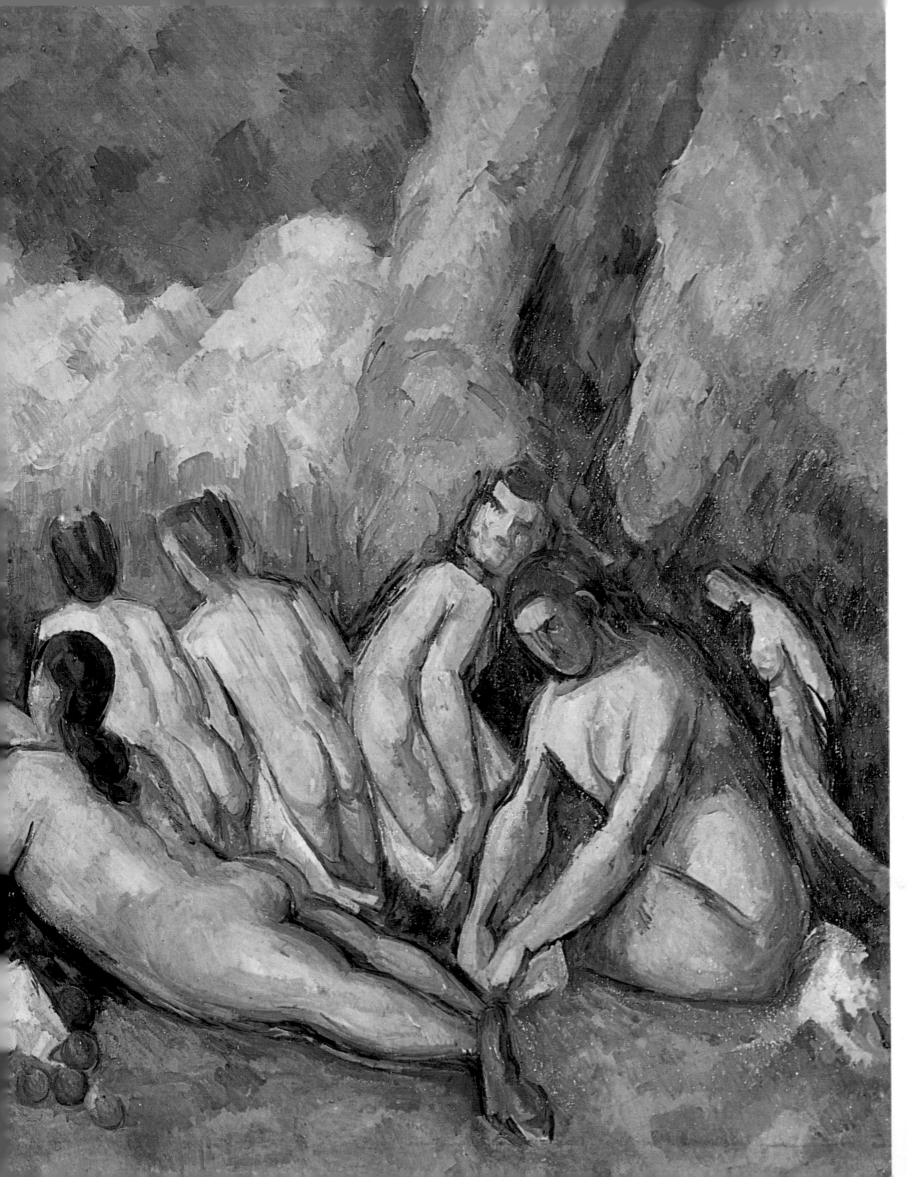

Pages 74–5. **Cézanne:** *The Bathers,* 127 × 196cm, 1904–6

In early life Cézanne had ambitions to paint large figurative works like those of Delacroix, but his lack of conventional draughtsmanship prevented him from ever seriously following in this direction. Nonetheless throughout his life he continued to paint the theme of bathers in a landscape, concentrating in his last years on a series of canvases of female nudes. In 1904, when engaged on these, he told the critic Émile Bernard that it would be difficult for him to copy from a young model, both because it might cause a scandal in Aix and, more importantly, that in middle age he felt a certain shyness in painting a naked girl. The subsequent stylized simplification of the body marked a new chapter in the history of nude painting, and was also a precursor of Cubism.

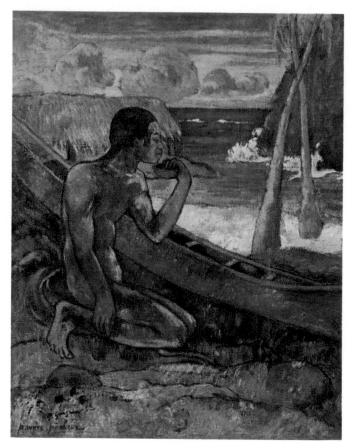

Gauguin: *The Poor Fisherman,* 74 × 66cm

which contains both specific references to Cézanne's *Bathers* and novel influences such as that of negro sculpture. The sense of unease experienced by the few who saw the work during its brief display in Picasso's studio in 1907, was perhaps as much due to the work's formal qualities as to its emotional spirit, which denied the human body its power of sensual consolation and portrayed a terrifying state of hysteria. Picasso's later approach to the nude did not consolidate this spirit, but was, in fact, as complex and varied as the whole development of art in this century. A well-known sensualist, all his life surrounded by women, Picasso's art certainly did not stand for the negation of human beauty. Typically, his work encouraged totally contradictory atti-

Gauguin: *Faa Iheihe* (detail)

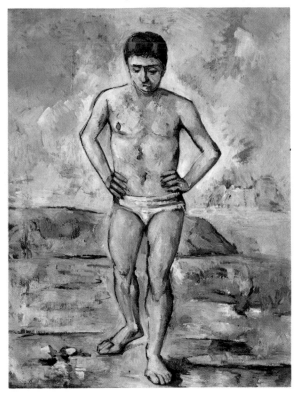

Cézanne: *The Bather,* 125 × 95cm, 1885-7

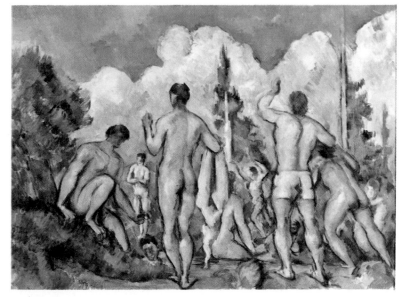

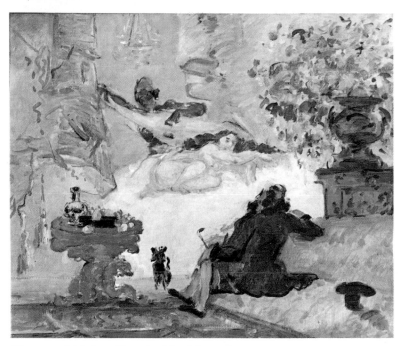

tudes towards the nude. On the other hand, the more intellectual side to Picasso's art resulted in works like Léger's *Nudes against a Red Background,* a twentieth-century equivalent of the academic nudes of the past, a work in which all the frightening potential of the human body has given way to the precision of a machine. On the other hand, the primitive fear of the body expressed in the *Demoiselles* was exploited by artists like the German Expressionists, for whom nakedness became almost a cult and whose desire to return to nature manifested itself in frequent nude picnics in the country near Dresden. The self-conscious nakedness of their works, totally different from the nude idylls of a Renoir or a Matisse, give the naked body psychological overtones. Photographs of the dancer Nina Hard dancing naked for the benefit of Kirchner and his circle, gives some idea of the intensely erotic impulse necessary to their art, but once again, this eroticism became inextricably linked with morbid fasci-

Cézanne: *A Modern Olympia,* 46 × 56cm
TOP **Cézanne:** *Bathers,* 22 × 33cm

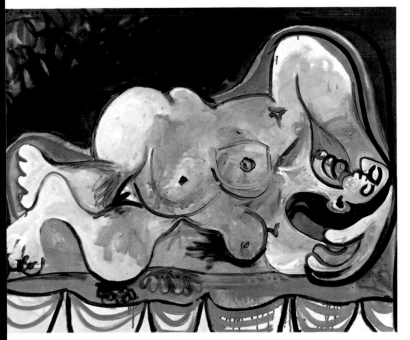

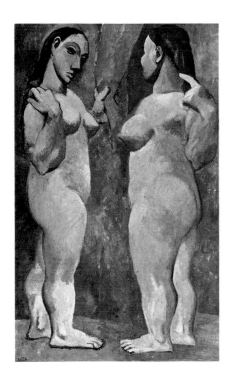

LEFT **Picasso:** *Woman Lying on a Couch,* 81 × 100cm

RIGHT **Picasso:** *Two Nudes,* 60 × 37cm, 1906

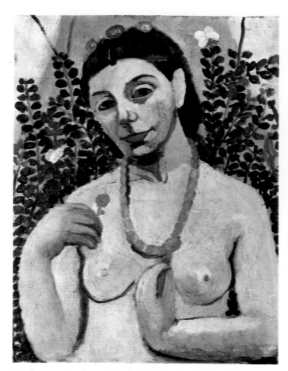

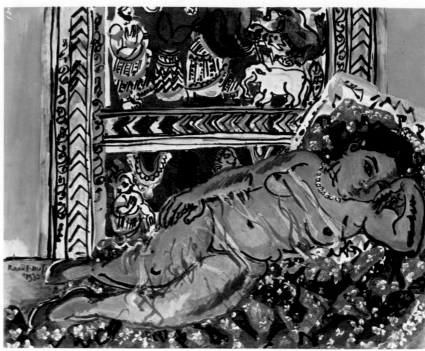

Modesson-Becker: *Nude Self-Portrait*, 61 × 50cm, c.1906

Dufy: *Nude Lying on a Couch*, 64·5 × 81·3cm

nation. This return to the spirit of the medieval nude, a spirit given psychological basis by Freud in his equation of fear of the body with a recognition of its mortality, was accompanied by a revival of the nude self-portrait. This type of painting became the speciality of Paula Modesson-Becker. But for perhaps its most powerful manifestation one has to turn to a work of the Austrian artist Schiele, entitled *The Family*, in which the artist and his wife are portrayed naked and most frighteningly vulnerable – a picture painted in fact

only one year before Schiele's death at the age of twenty-eight.

So many barriers interfere between ourselves and a purely sensual enjoyment of the nude that the sense of ecstatic happiness, which the painting of naked bathers inspired in the young Stendhal, seems an emotion rarely to be savoured. Religion, morality or deep-rooted psychological fears, all sometimes give way to the even greater barrier of culture. The principal role of nude painting which was once a stimu-

Delvaux: *La Voie Publique*, 152·5 × 254cm, 1948

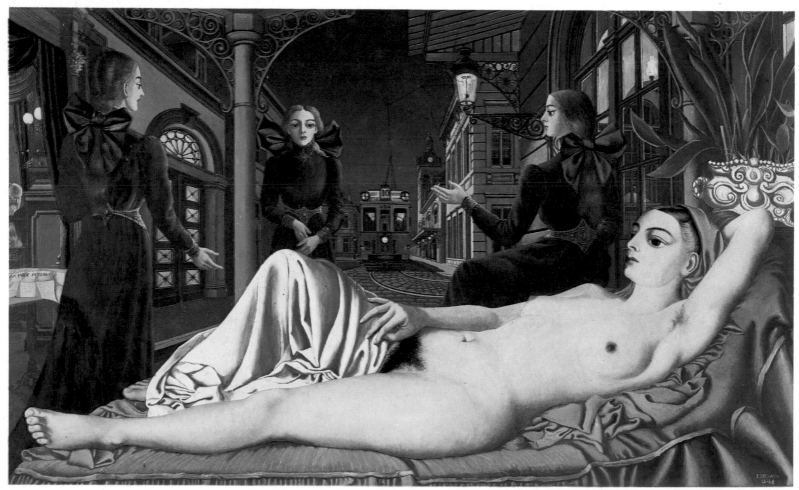

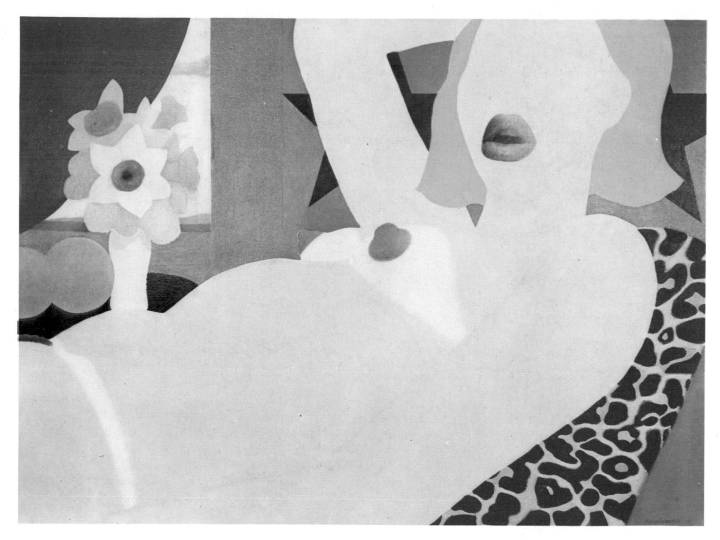

lus, provoking, arousing and at times revolutionary, has been usurped by the new representational forms of photography and the cinema media which through the exact reproduction of the human body have made us unwilling to accepted painted substitutes. Canvases no longer shock us; we approach them with precious detachment and a sense of relief that all their passion, erotic or otherwise, has been safely contained within the boundaries of art, or, in the case of this book, neatly arranged on the coffee-table.

Wesselmann: *Great American Nude, No. 57,* 130×165cm, 1964

The Venuses, Dianas, Bathshebas, or bathers of the past, are no different in spirit to 'the girl next door', the pornographic centrefold inspiration behind Wesselmann's supposed critique of popular culture today.

LEFT Leger: *Nudes against a Red Background,* 146·5 × 98cm, 1923

Bomberg: *The Mud Bath,* 152 × 224cm, 1912–13

List of Illustrations

Bibliography

BOIME, ALBERT: *Academy and French Painting in the Nineteenth Century*, 1970
CLARK, KENNETH: *The Nude, a Study in Ideal Form*, 1956
Ed. HESS, THOMAS and NOCHLIN, LINDA: *Woman as Sex Object*, 1973
PEVSNER, NIKOLAUS: *Academies of Art, Past and Present*, 1940
WEBB, PETER: *The Erotic Arts*, 1975